Pretty Patterns

TO PAINT

More than 25 whimsical poster-size patterns to paint & color

Walter Foster

Contents

Quarto is the authority on a wide range of topics.
Quarto educates, entertains, and enriches the lives of our readers—
enthusiasts and lovers of hands-on living.
www.quartoknows.com

© 2016 Quarto Publishing Group USA Inc.
Published by Walter Foster Publishing,
a division of Quarto Publishing Group USA Inc.
All rights reserved. Walter Foster is a registered trademark.

Original patterns by Zeline Benitez
Colored designs, photographs, and tips and techniques by Elizabeth T. Gilbert

Walter Foster

6 Orchard Road, Suite 100
Lake Forest, CA 92630
quartoknows.com
Visit our blogs at quartoknows.com

Printed in China
3 5 7 9 10 8 6 4 2

Introduction

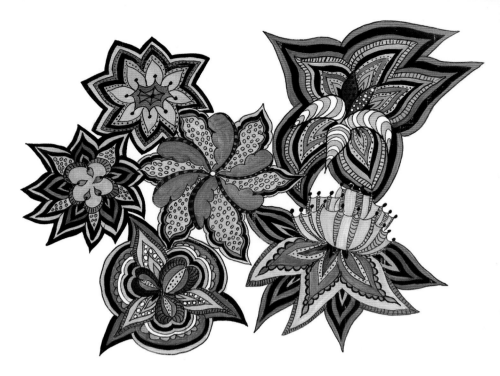

Ready to take your coloring skills to the next level? Adding paint to the mix will challenge and reinvigorate coloring enthusiasts of all skill levels. *Pretty Patterns to Paint* encourages coloring graduates to create whimsical, colorful masterpieces using a combination of colored pencil, marker, pastel, acrylic, and watercolor. Simply tear out the patterns and choose your materials, based on the tips and techniques provided on pages 4-16. To preserve your templates, try transferring them onto a separate sheet of paper using the steps below.

Using the Templates

Pretty Patterns to Paint encourages you to paint and color directly on the templates provided on pages 17-71. The templates work best using colored pencil, marker, acrylic, and flat washes of watercolor. To create large areas of wet-into-wet blends, transfer the template to sized watercolor paper for the best results. For an extra challenge, fill the unfinished templates on pages 63-71 with your own patterns and designs.

Transferring a Template

Use your templates again and again by transferring them to separate sheets of paper, watercolor paper, or canvas using tracing paper or graphite paper.

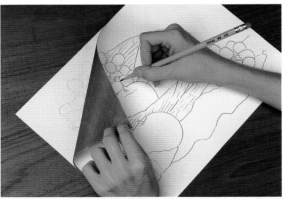

Trace the template onto a sheet of **tracing paper**, or make a photocopy of the template onto a sheet of copy paper, scaling it to your desired size. Coat the back of the paper with a layer of graphite using a pencil. Place the template graphite-side down over your art paper or canvas. Using a pencil, trace the template lines. The result will create a light guideline for you to follow.

Graphite paper is coated on one side with graphite, making it easy to transfer a light line drawing to your chosen surface. Place a sheet of graphite paper over clean drawing paper or canvas. Place the template over the graphite paper and lightly trace the outline. The lines of your sketch will transfer onto the surface below.

Colored Pencil

Colored pencils are a perfect starting point for beginning artists. Colored pencil works well on many surfaces, from smooth drawing paper to toned paper or Bristol board. A set of 24 wax-based colored pencils offers a good variety of color for beginners, covering the spectrum of color plus white, black, gray, and brown. This poinsettia-like drawing calls for a palette of red and green.

TIPS AND TECHNIQUES

Varying Strokes Experiment with the tip of your pencil as you create a variety of marks, from tapering strokes to circular scribbles.

Gradating To create a gradation with one color, stroke side to side with heavy pressure and lighten the pressure as you move away, exposing more of the white paper beneath the color.

Layering You can optically mix colored pencils by layering them lightly on paper. In this example, observe how layering yellow over blue creates green.

Blending To blend one color into the next, lighten the pressure of your pencil and overlap the strokes where the colors meet.

Hatching & Crosshatching Add shading and texture to your work with hatching (parallel lines) and crosshatching (layers of parallel lines applied at varying angles).

Stippling Apply small dots of color to create texture or shading. The closer together the dots, the darker the stippling will "read" to the eye.

Burnishing For a smooth, shiny effect, burnish by stroking over a layer with a colorless blender, a white colored pencil (to lighten), or another color (to shift the hue) using heavy pressure. Burnishing pushes the color into the tooth and distributes the pigment for smooth coverage.

Scumbling Create this effect by scribbling your pencil over the surface of the paper in a random manner, creating an organic mass of color. Changing the pressure and the amount of time you linger over the same area will increase or decrease the value of the color.

Colored pencil does not lift from the paper as easily as graphite or charcoal—
some residue will almost always stay behind. If you must erase, an electric vinyl eraser is best.

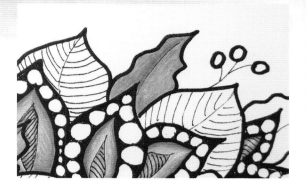

◄ Begin the leaf with a blue base to achieve a cool, rich undertone. Then apply a layer of green. To finish, add form to the leaf by adding shadows with a darker green.

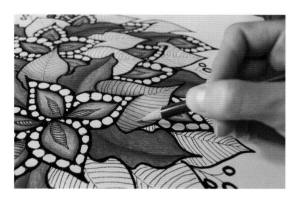

◄ Lay a flat green over the leaf, and then layer the tip with yellow. Deepen the bottom of the leaf with a layer of darker green for dimension.

Consider accenting your art with glitter glue, which provides extra texture and sparkle.

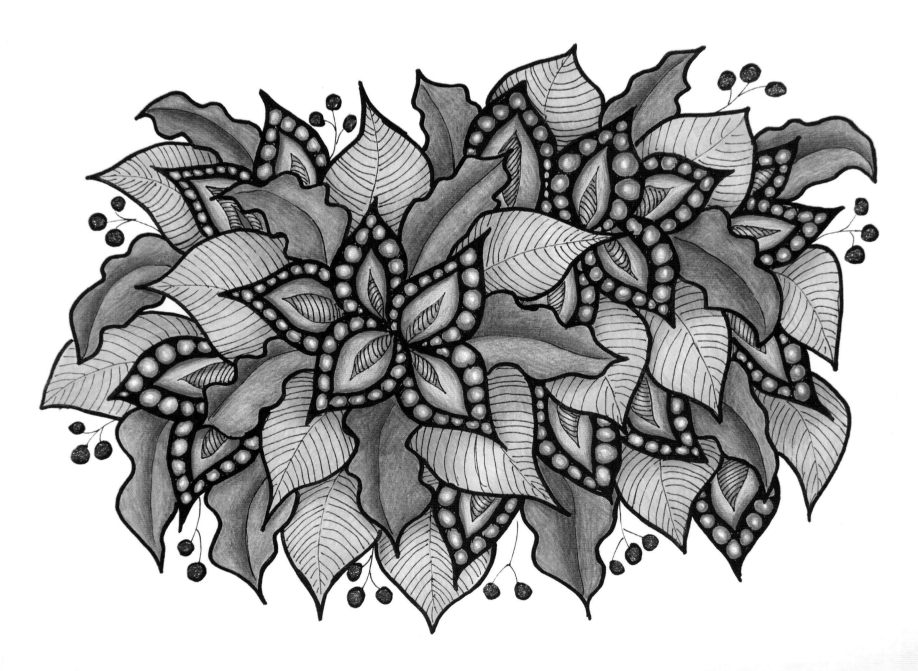

Marker

Don't know where to start? Begin by choosing your color palette (or selection of colors). This will help you stick to dynamic color combinations while helping you avoid the chaos of too many color options. Think about what subject comes to mind when you look at the line art. Flowers? Foliage? Coral reef? In this example, a palette of blues and greens accented with coral pink echoes an underwater world.

TIPS AND TECHNIQUES

Color Mixing To mix colors with felt-tip markers, use the lightest color first. Then add the darker color.

Hatching Use a series of roughly parallel lines. The closer the lines are to each other, the denser and darker the color.

Stippling Apply small dots all over the areas you want to color. For denser coverage, apply the dots closer together.

Crosshatching Lay one set of hatched lines over another, but in a different direction.

Use the best marker tip for the space. Brush tips are great for following curves or covering large areas with flat color, whereas fine tips are best for small areas and details. Brush tips are also great for long, flowing, tapering lines; vary the angle to adjust the width of your stroke.

Consider adding your own texture within larger areas of white. Stippling, crosshatching, and gradating with color adds interest.

Remember that it's okay to leave some parts of the drawing pure white. These areas will help retain overall contrast as you add color to your piece of art.

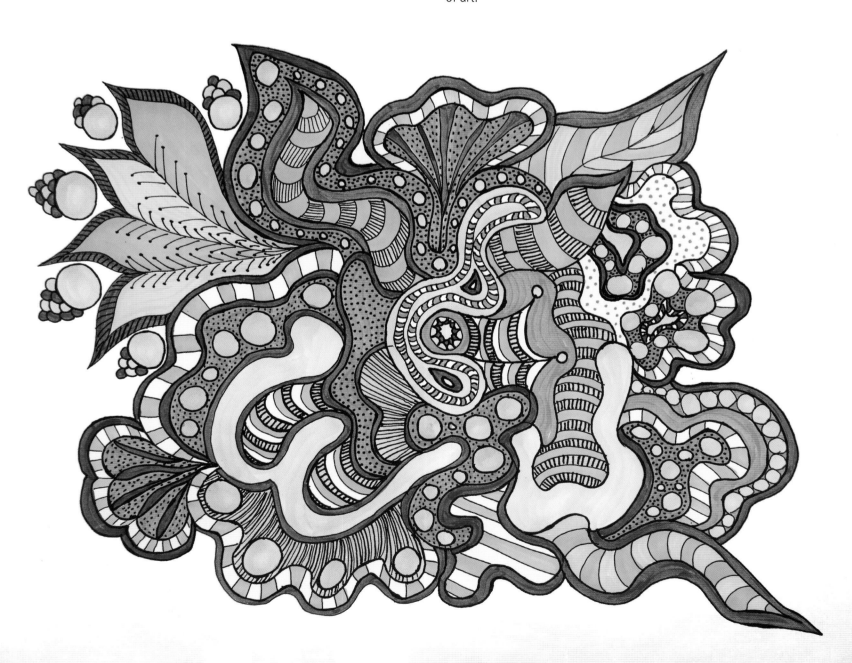

Pastel

Soft pastel has a chalky feel that can yield soft blends. Be sure to work on paper that has a textured surface so the raised areas catch and hold the pastel. You can also use toned paper, which can enrich the color with a subtle hue that prevents the white paper from showing through. Refer to page 3 for directions on how to transfer a template to art paper.

TIPS AND TECHNIQUES

Unblended Strokes To transition from one color to another, allow your strokes to overlap where they meet. Leaving them unblended creates a raw, energetic feel and maintains the rhythm of your strokes.

Blending To create soft blends between colors, begin by overlapping strokes where two colors meet. Then pass over the area several times with a tissue, chamois, or stump to create soft blends.

Scumbling This technique involves scribbling to create a mottled texture with curved lines. Scumble over blended pastel for extra depth.

Stroking over Blends You can create rich colors and interesting contrasts of texture by stroking over areas of blended pastel.

Gradating A gradation is a smooth transition of one tone into another. To create a gradation using one pastel, begin stroking with heavy pressure and lessen your pressure as you move away from the initial strokes. Above is white gradated over a blue textured paper, lightly blended with a tissue.

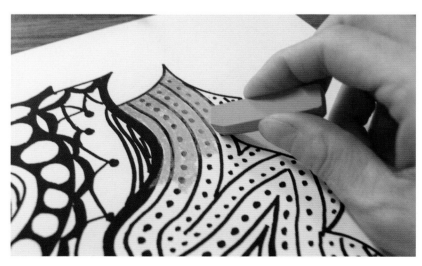

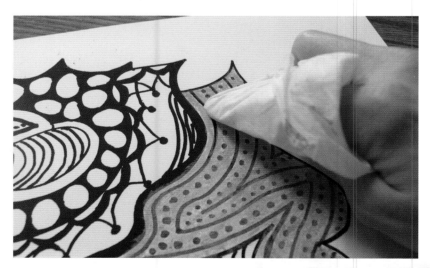

Fill in your chosen area with strokes of pastel. In each section, apply two to three colors to give it movement and a soft, psychedelic flair.

Use a tissue to blend and smooth the strokes, blowing away the crumbs when necessary. Rubbing with a tissue also recovers some of the black line drawing from beneath the pastel.

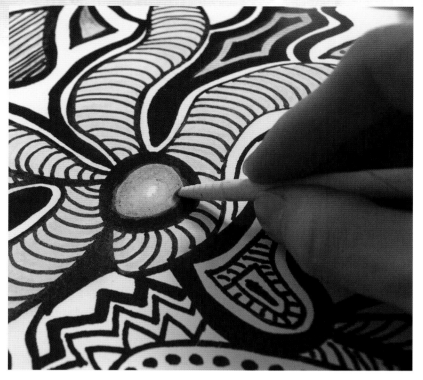

Use a blending stump or tortillon to blend the pastel in small areas.

The hardness of pastel
sticks can scratch the
black line drawing of the
templates, so be careful not
to be too heavy-handed
with your strokes.

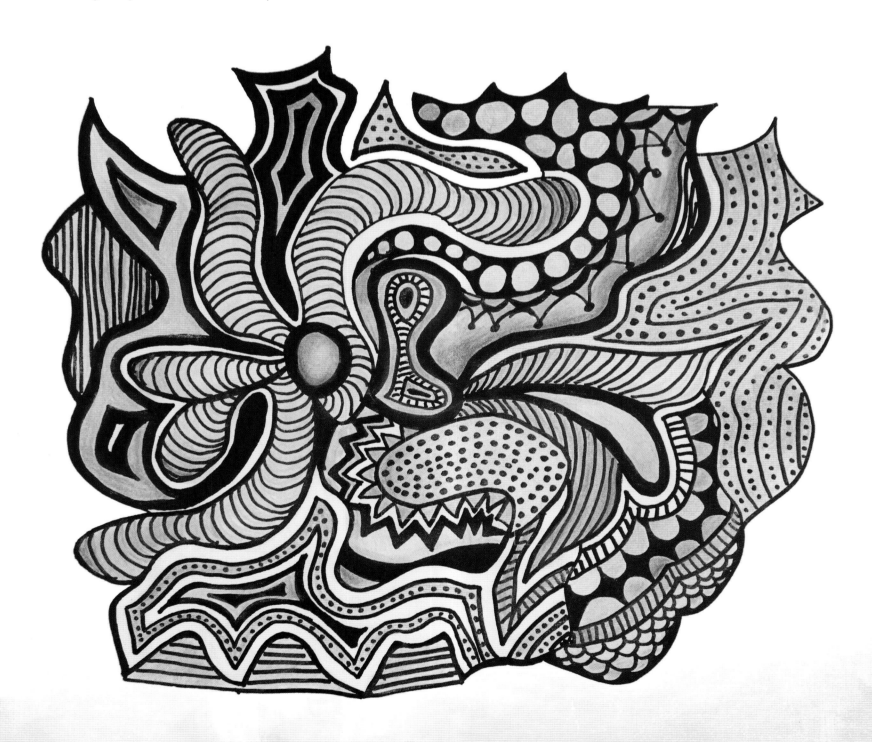

Acrylic

Acrylic is a water-soluble paint that is easy to work with and perfect for beginners. It works well on a variety of surfaces, including canvas and watercolor paper. Acrylic paint colors can be mixed and blended for a more painterly look, or thinned with water to create light washes and highlights. Try using acrylic ink for the finer details of your design.

TIPS AND TECHNIQUES

Flat Wash To create a thin wash of flat color, thin the paint and stroke it evenly across your surface. For large areas, stroke in overlapping horizontal bands, retracing strokes when necessary to smooth out the color.

Glazing You can apply a thin layer of acrylic over another color to optically mix the colors. Soft gels are great mediums for creating luminous glazes. Shown here are ultramarine blue (left) and lemon yellow (right) glazed over a mix of permanent rose and Naples yellow.

Graduated Blend To create a gradual blend of one color into another, stroke the two different colors onto the canvas horizontally, leaving a gap between them. Continue to stroke horizontally, moving down with each stroke to pull one color into the next. Retrace your strokes where necessary to create a smooth blend between colors.

Drybrushing Load your brush and then dab the bristles on a paper towel to remove excess paint. Drag the bristles lightly over your surface so that the highest areas of the canvas or paper catch the paint and create a coarse texture. The technique works best when used sparingly.

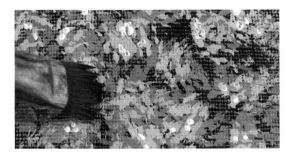

Dabbing Load your brush with thick paint and then use press-and-lift motions to apply irregular dabs of paint to your surface. For more depth, apply several layers of dabbing, working from dark to light. Dabbing is great for suggesting foliage and flowers.

Scumbling This technique refers to a light, irregular layer of paint. Load a brush with a bit of slightly thinned paint, and use a scrubbing motion to push paint over your surface.

Sponging Applying paint by dabbing with a sponge can create interesting, spontaneous shapes. Layer multiple colors to suggest depth. You can also use sponges to apply flat washes with thinned paint.

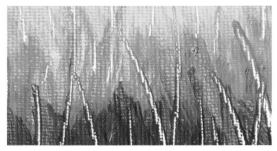

Scraping Create more detailed designs by scraping away paint. Using the tip of a painting knife or the end of a brush handle, "draw" into the paint to remove it from the canvas. For tapering strokes that suggest grass, stroke swiftly and lift at the end of each stroke.

Stippling Apply small, closely placed dots of paint. The closer the dots, the finer the texture and the more it will take on the color and tone of the stippled paint. You can also use stippling to optically mix colors; for example, stippling blue and yellow in an area can create the illusion of green. You can dot on paint using the tip of a round brush, or you can create more uniform dots by using the end of a paintbrush handle.

This project uses both thickly applied acrylic and acrylic ink; however, you can also use thinned acrylic (so that it doesn't cover the black lines) for an alternative, less painterly look.

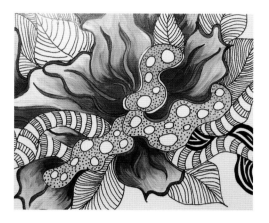

◄ For the flowing flowers, blend a deep purple into white as you move toward the tip of each petal. Keep your strokes loose to create a painterly gradation. To allow the template design to show through, keep your washes thin.

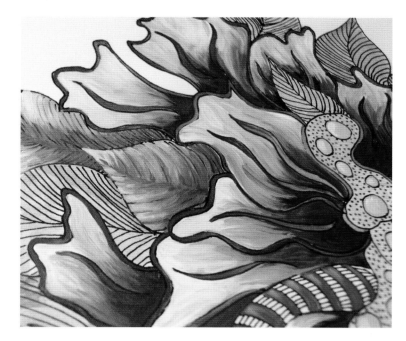

◄ For the turquoise stripes, try using acrylic ink, which is easier to apply within the more graphic areas of the design. Give the design a rounded form by highlighting with strokes of turquoise ink mixed with white.

Apply a light wash of green acrylic over the leaves to tone the paper. Give the leaves a painterly feel, like the flower petals, by building up the green with thicker paint and looser strokes. Toward the edges and tips of the leaves, add white into the strokes for soft highlights that give each leaf dimension.

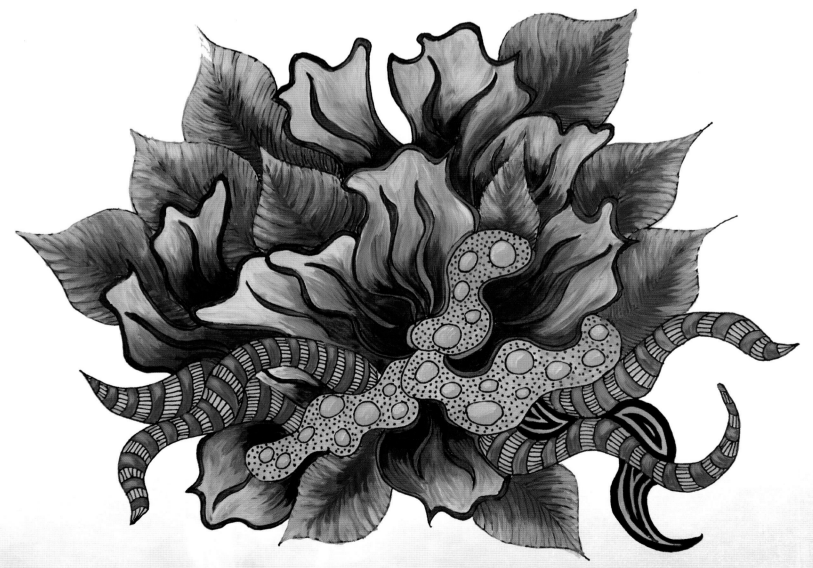

Watercolor

Watercolor's airy and atmospheric qualities set it apart from other painting media. This fluid medium requires a bit of practice to master, but with enough time you will soon discover how to quickly suggest form and color with just a few brushstrokes. Watercolor is available in tubes, pans, semi-moist pots, and pencils. Use sable brushes or soft-hair synthetic brushes to work in watercolor.

TIPS AND TECHNIQUES

Flat Wash A flat wash is a thin layer of paint applied evenly to your paper. First wet the paper, and then load your brush with a mix of watercolor and water. Stroke horizontally across the paper and move from top to bottom, overlapping the strokes as you progress.

Spattering First cover any area you don't want to spatter with a sheet of paper. Load your brush with a wet wash and tap the brush over a finger to fling droplets of paint onto the paper. You can also load your brush and then run the tip of a finger over the bristles to create a spray.

Gradated Wash A gradated (or graduated) wash moves slowly from dark to light. Apply a strong wash of color and stroke in horizontal bands as you move away, adding water to successive strokes.

Drybrushing Load your brush with a strong mix of paint, and then dab the hairs on a paper towel to remove excess moisture. Drag the bristles lightly over the paper so that tooth catches the paint and creates a coarse texture.

Using Salt For a mottled texture, sprinkle salt over a wet or damp wash. The salt will absorb the wash to reveal the white of the paper in interesting starlike shapes. The finer the salt crystals, the finer the resulting texture. For a similar but less dramatic effect, simply squirt a spray bottle of water over a damp wash.

Wet-into-Wet Stroke water over your paper and allow it to soak in. Wet the surface again and wait for the paper to take on a matte sheen; then load your brush with rich color and stroke over your surface. The moisture will grab the pigments and pull them across the paper to create feathery soft blends.

Tilting To pull colors into each other, apply two washes side by side and tilt the paper while wet so one flows into the next. This creates interesting drips and irregular edges.

Applying with a Sponge In addition to creating flat washes, sponges can help you create irregular, mottled areas of color.

Using Alcohol To create interesting circular formations within a wash, use an eyedropper to drop alcohol into a damp wash. Change the sizes of your drops for variation.

Because there are so many separate elements to this design, limit the palette to three secondary colors, such as green, purple, and orange. Try using the same template with three different complementary colors for a unique look.

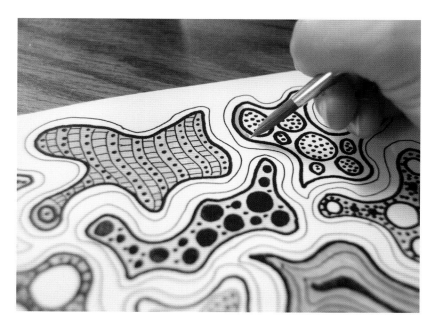

Fill in each element of the design with your chosen colors, applying the washes evenly. You may choose to work around some of the larger circles, filling them in with a different color. Allow to dry.

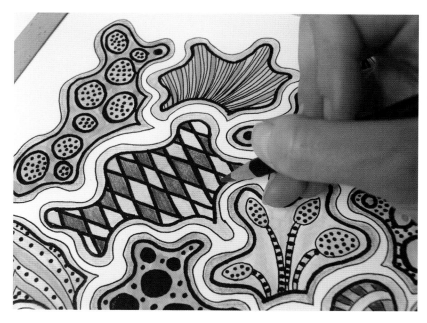

Use colored pencil to fill in the finer areas, such as thin outlines, and bring out the details in the patterns.

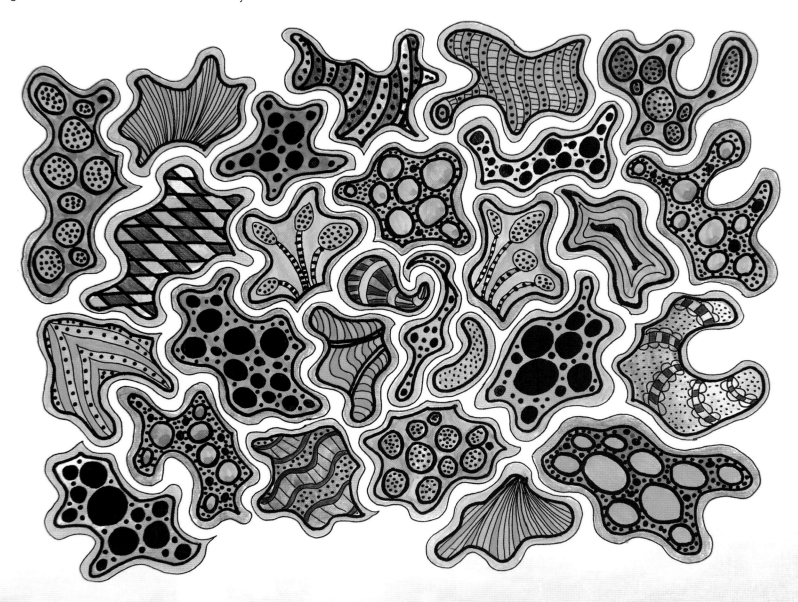

Watercolor Pencil

Watercolor pencil can create the smooth blends of watercolor with the control of a pencil. However, it's not quite as precise as colored pencil once you introduce water, so allowing oneself a looser approach is helpful—especially when working in tiny areas!

TIPS AND TECHNIQUES

Dry Tip Use a sharp, dry tip for details and small spaces.

Wet Tip Use a wet pencil tip for smooth lines.

Wet Brush Use a wet brush to blend the strokes.

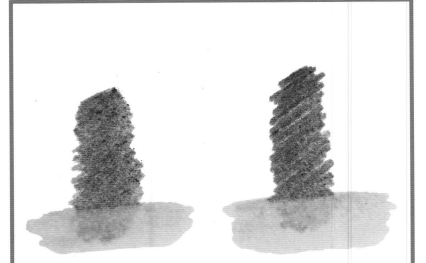

An example of watercolor pencil with a wet brush over the strokes.

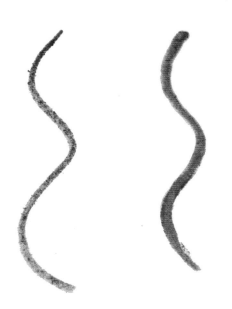

An example of pencil applied dry (left) and wet (right). Simply wet the tip of the pencil by dipping it in a small pool of water. The wet pencil stroke is smoother and a little more vibrant; however, it's more difficult to be precise.

◄ Apply dry watercolor pencil in the manner of plain colored pencil. Use gradations of watercolor pencil to create dimension and movement within white spaces.

◄ Use a wet brush to blend the strokes and gradations of color. Then use a sharp, dry watercolor pencil tip for the details.

Use a fine silver marker to create metallic accents throughout.

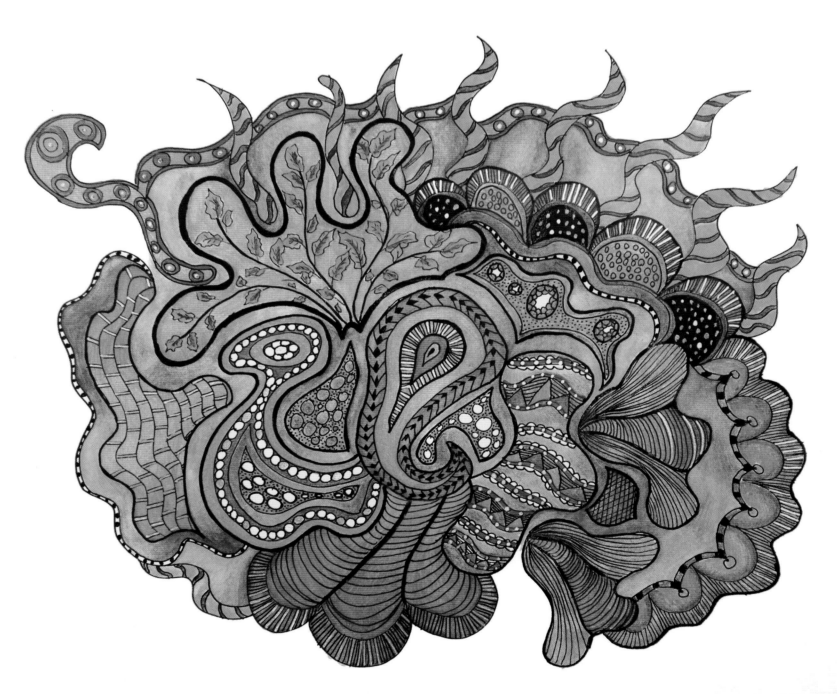

Mixed Media

Using an assortment of media allows the design to really stand out. Watercolor, marker, and colored pencil are used in this project, but try experimenting with a variety of tools for a one-of-a-kind look.

◀ Use watercolor to tone the largest areas of the design. Allow to dry. The other media can be applied directly on top to create detail and form.

◀ Use colored pencils to fill in the smaller areas of detail with subtle gradations.

Use marker for the boldest details.

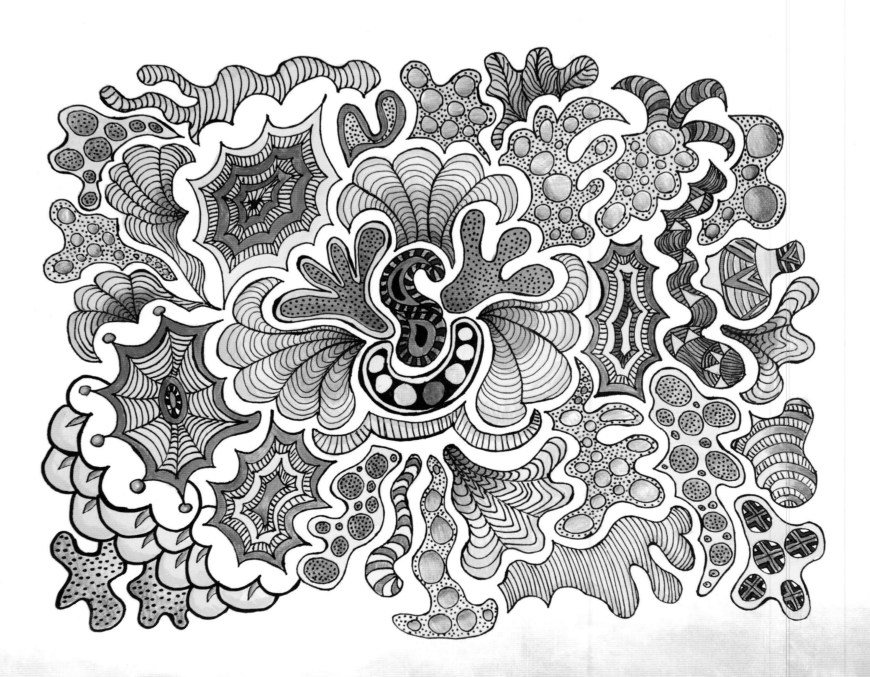

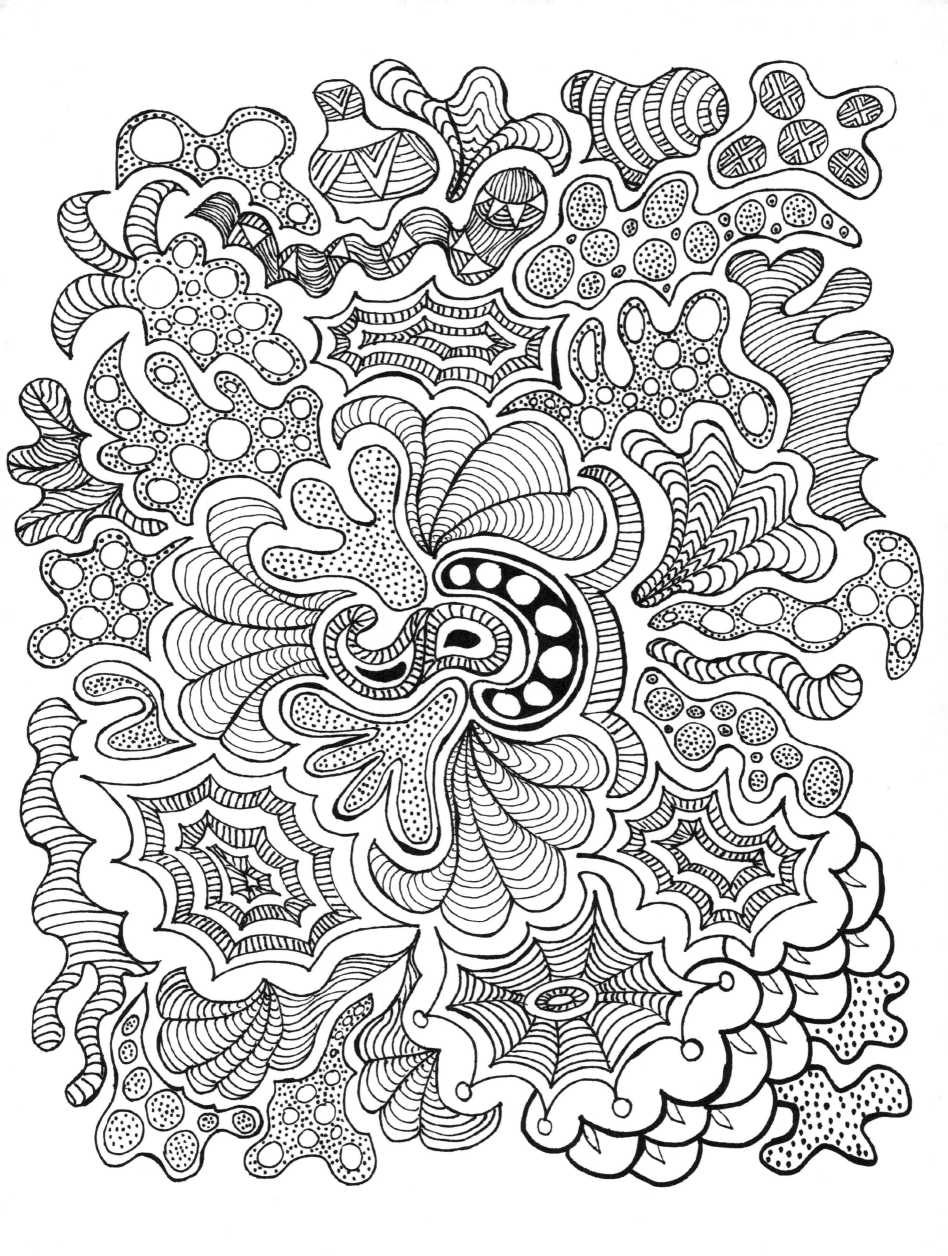

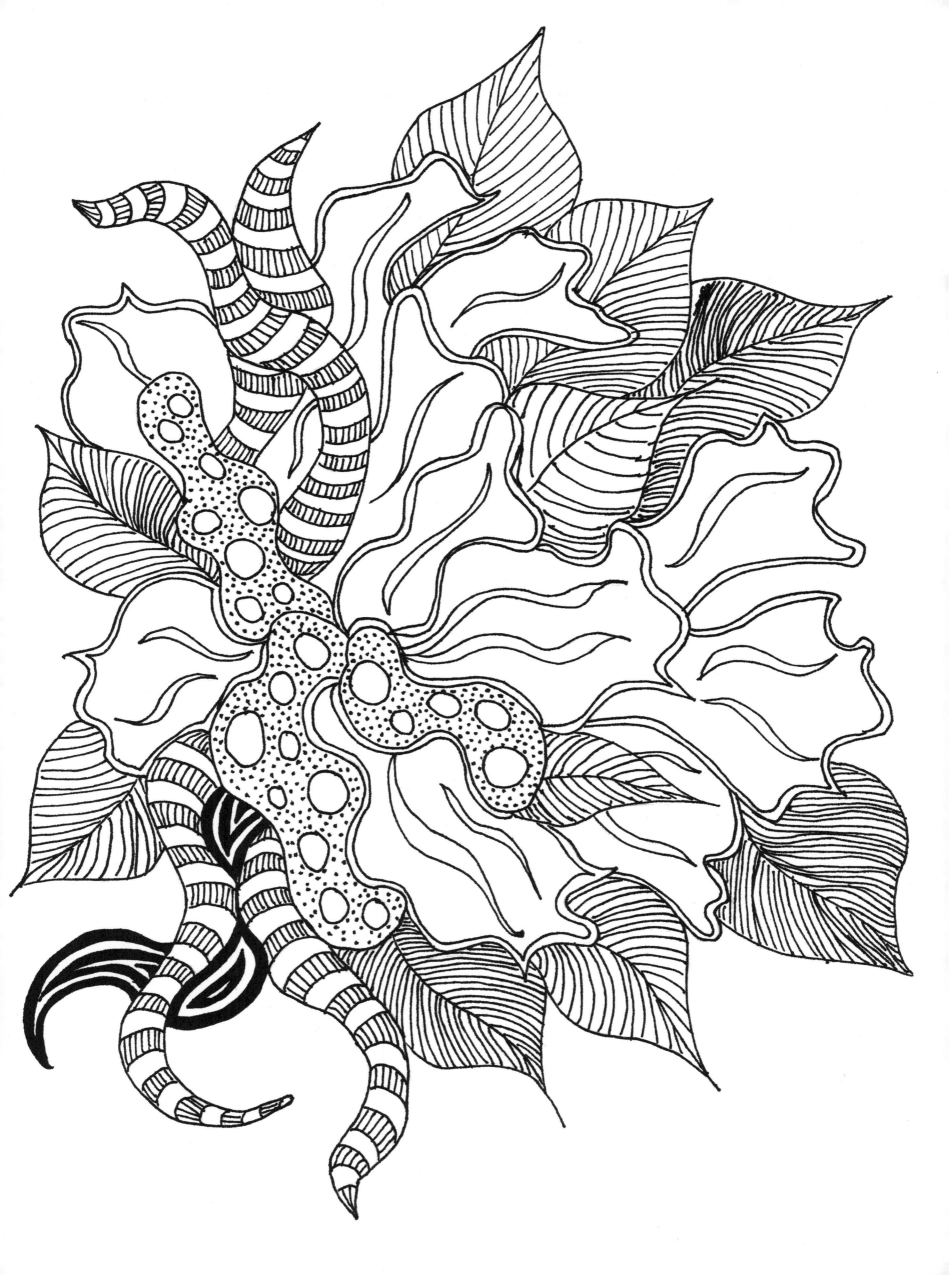

20

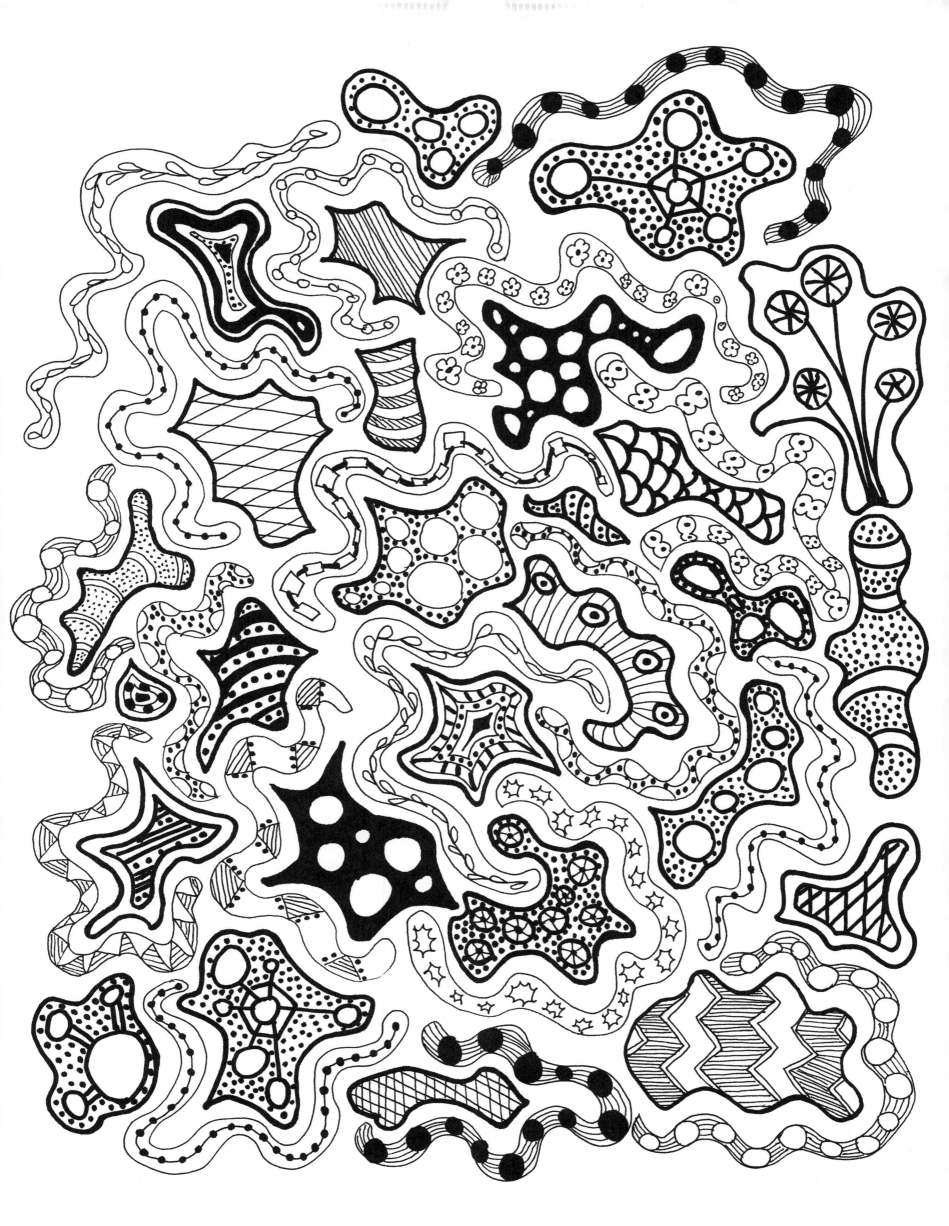

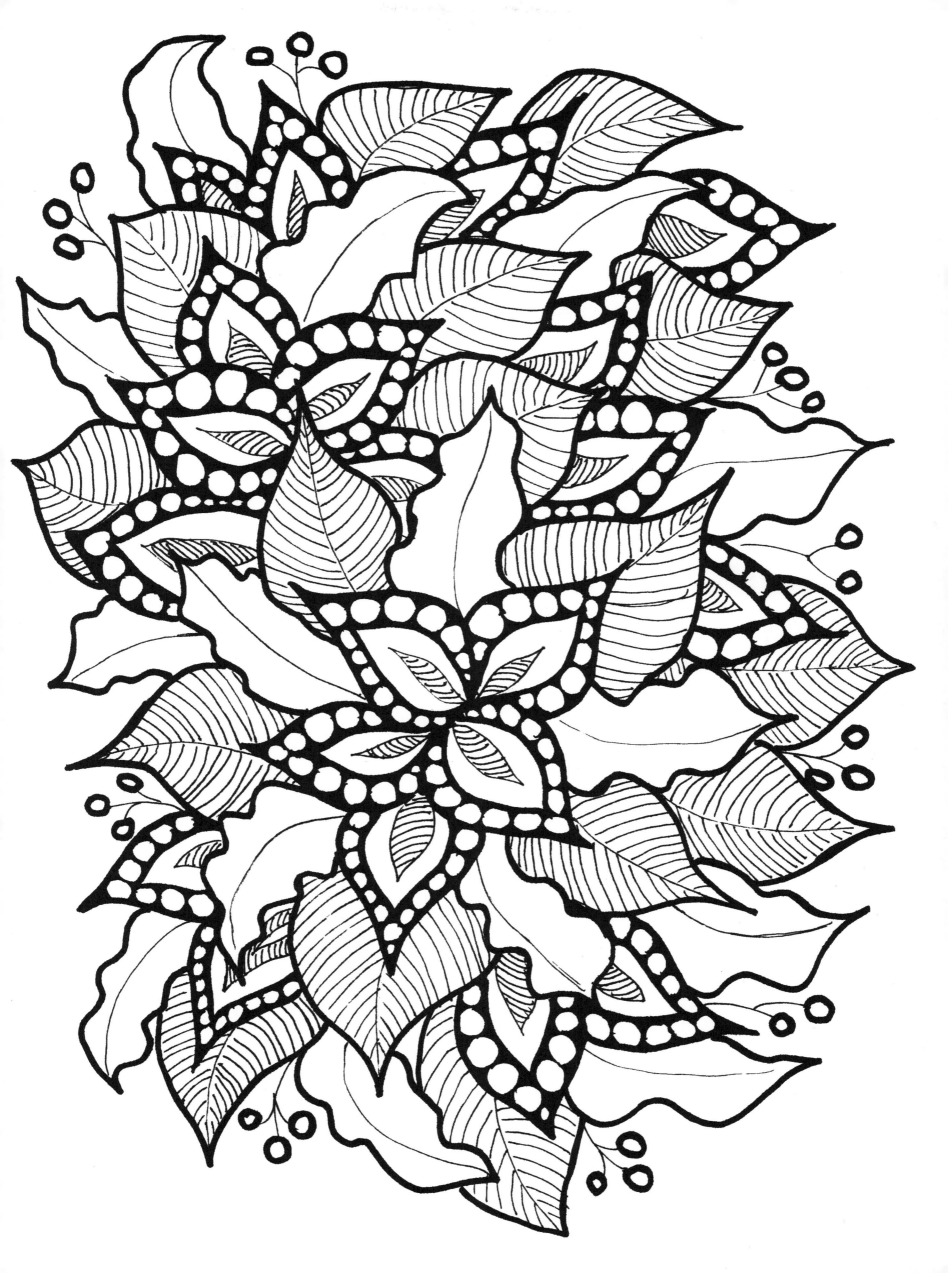

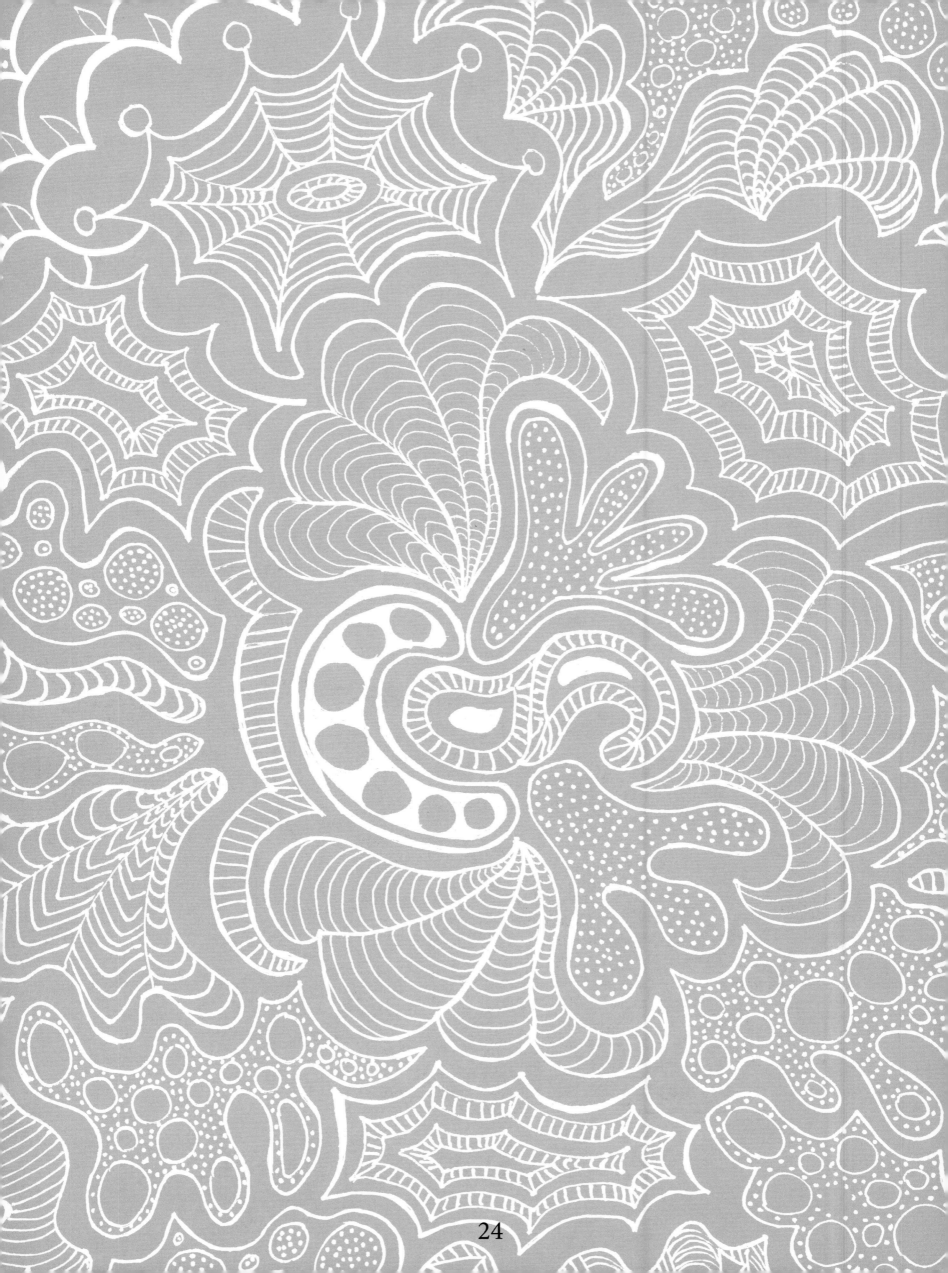

24

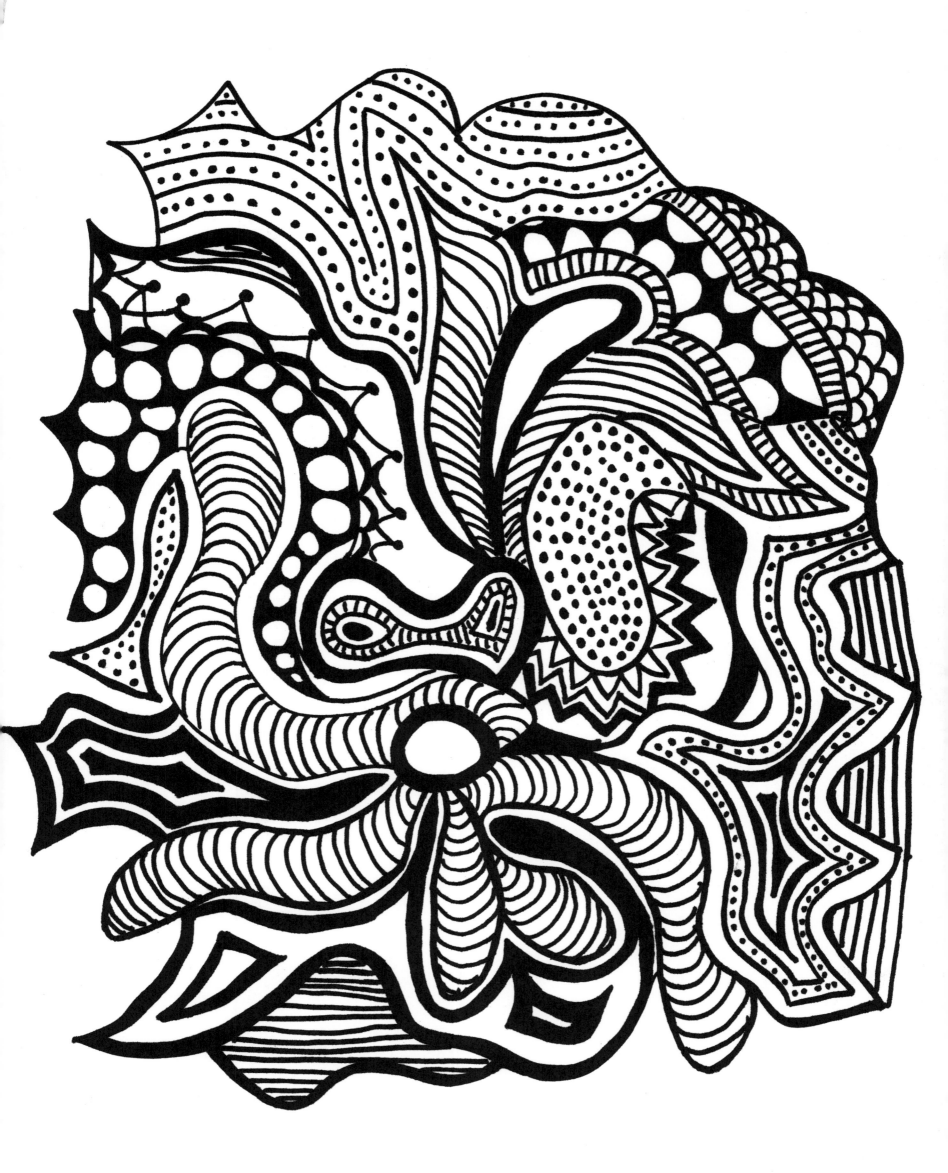

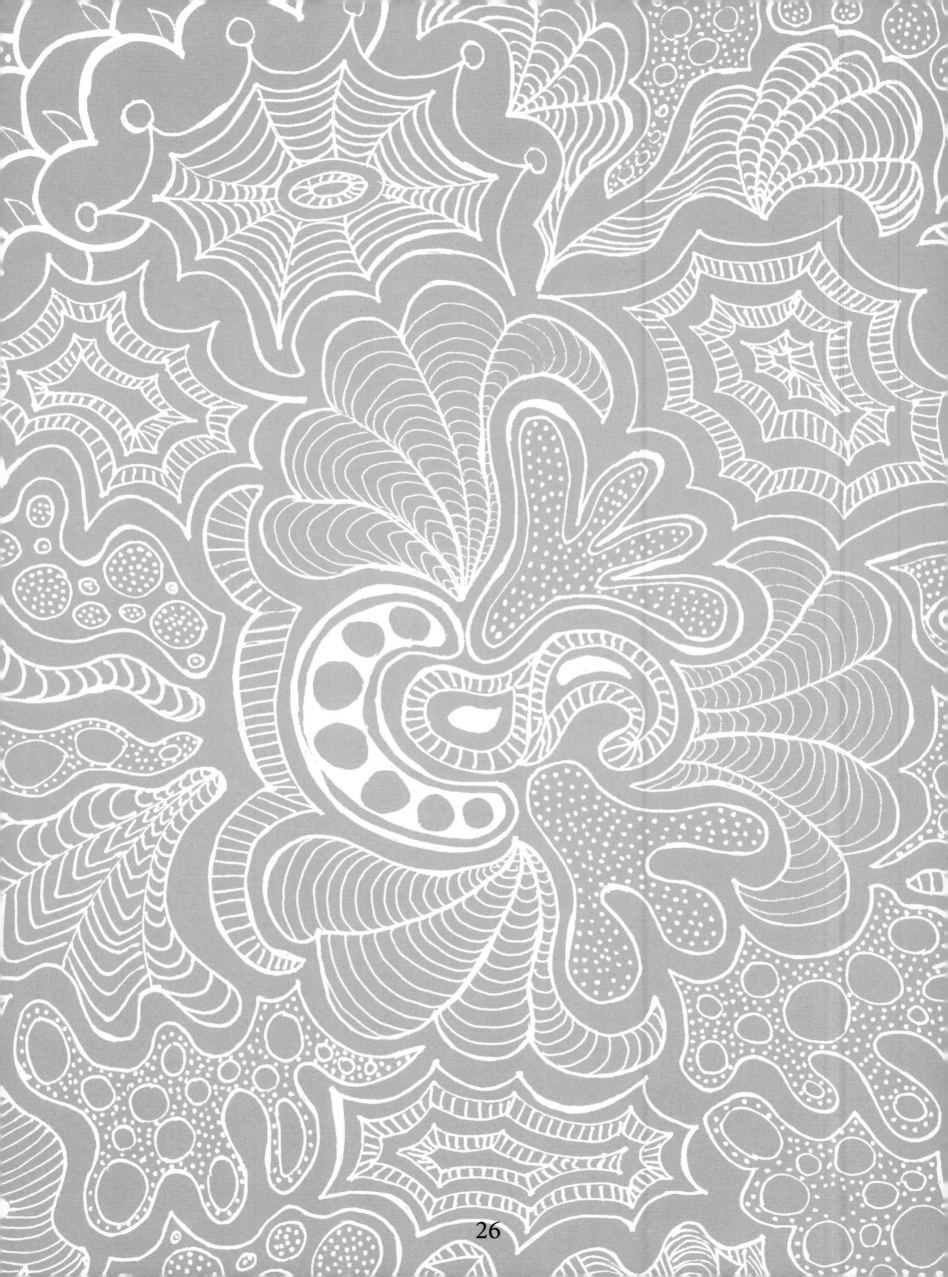

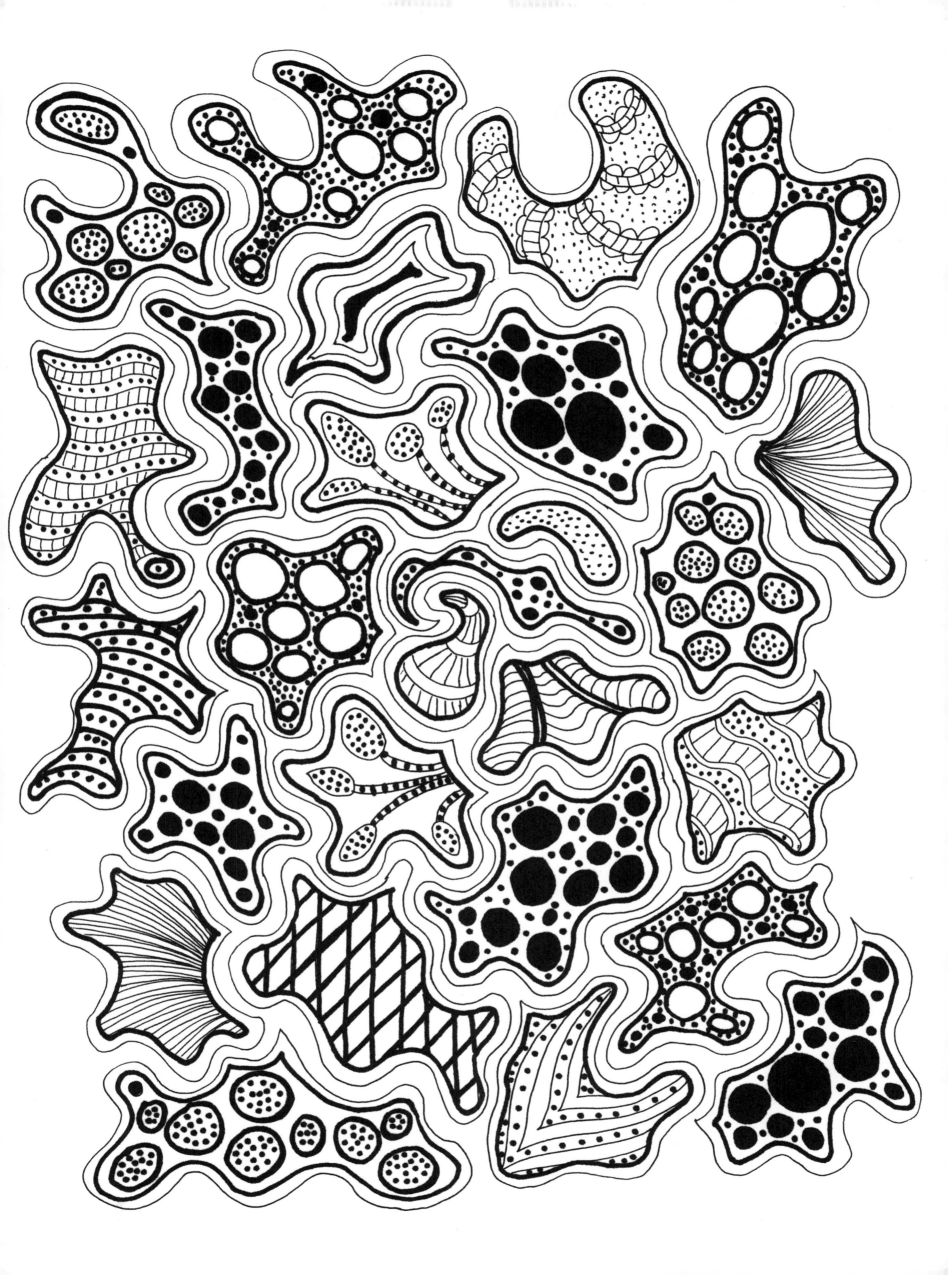

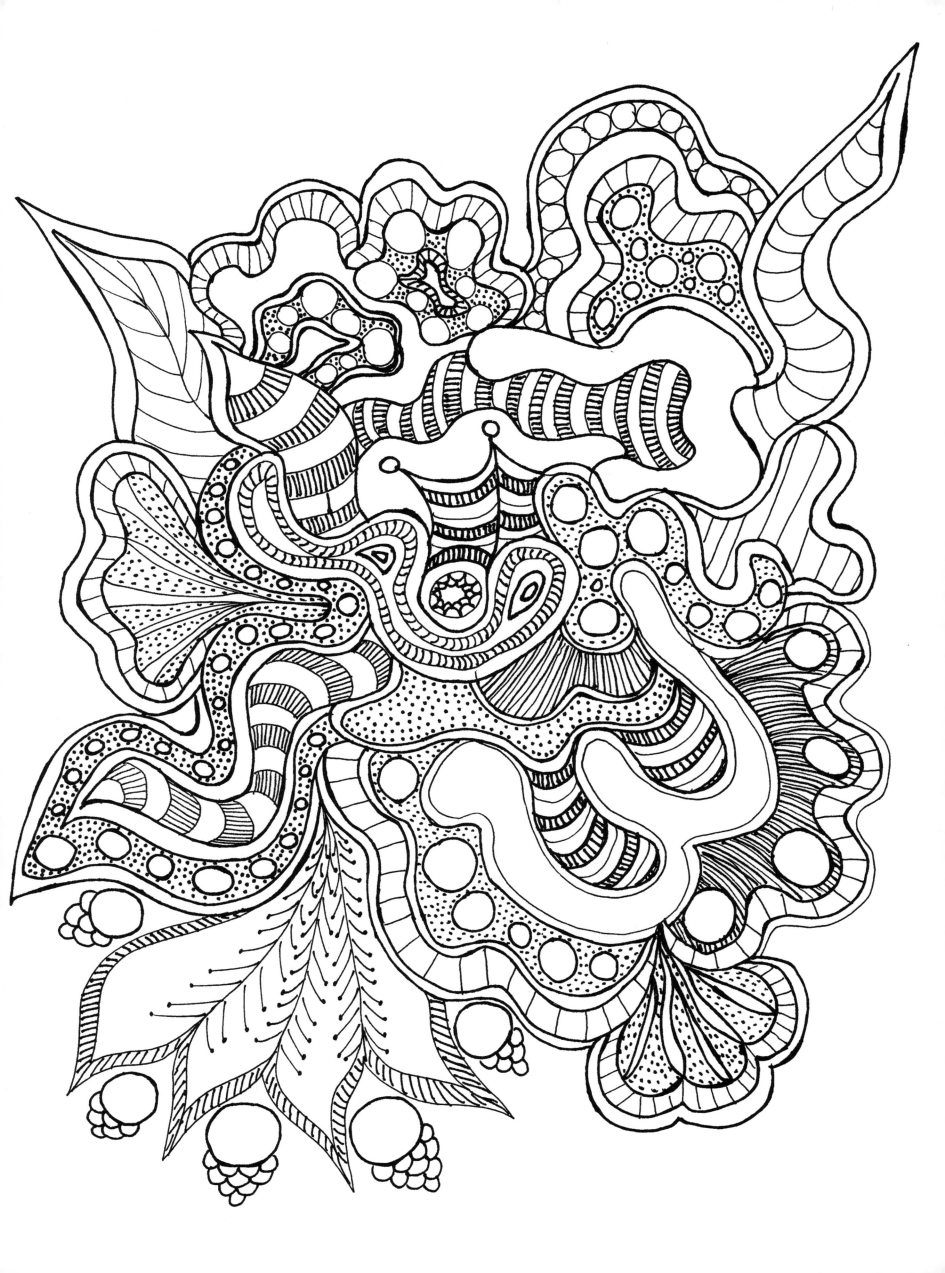

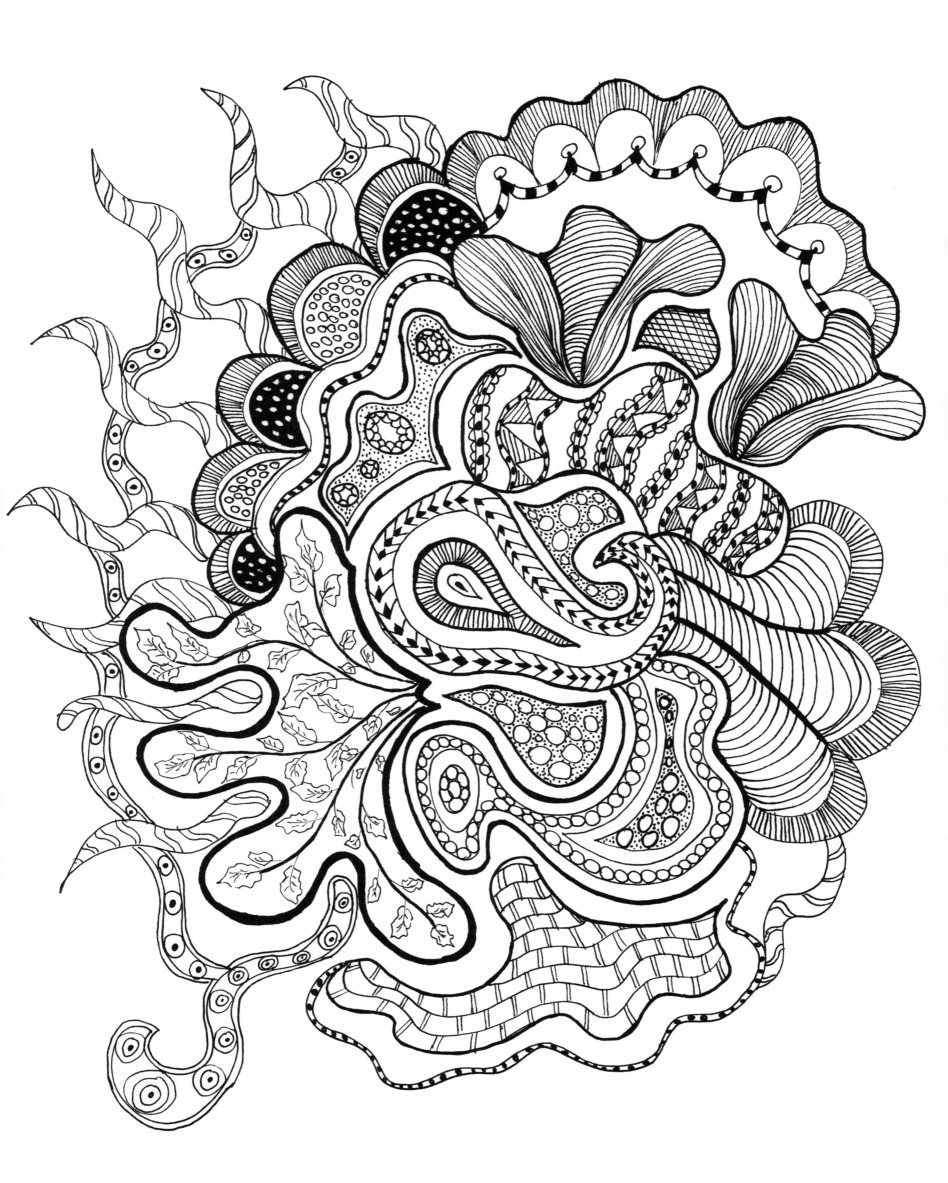

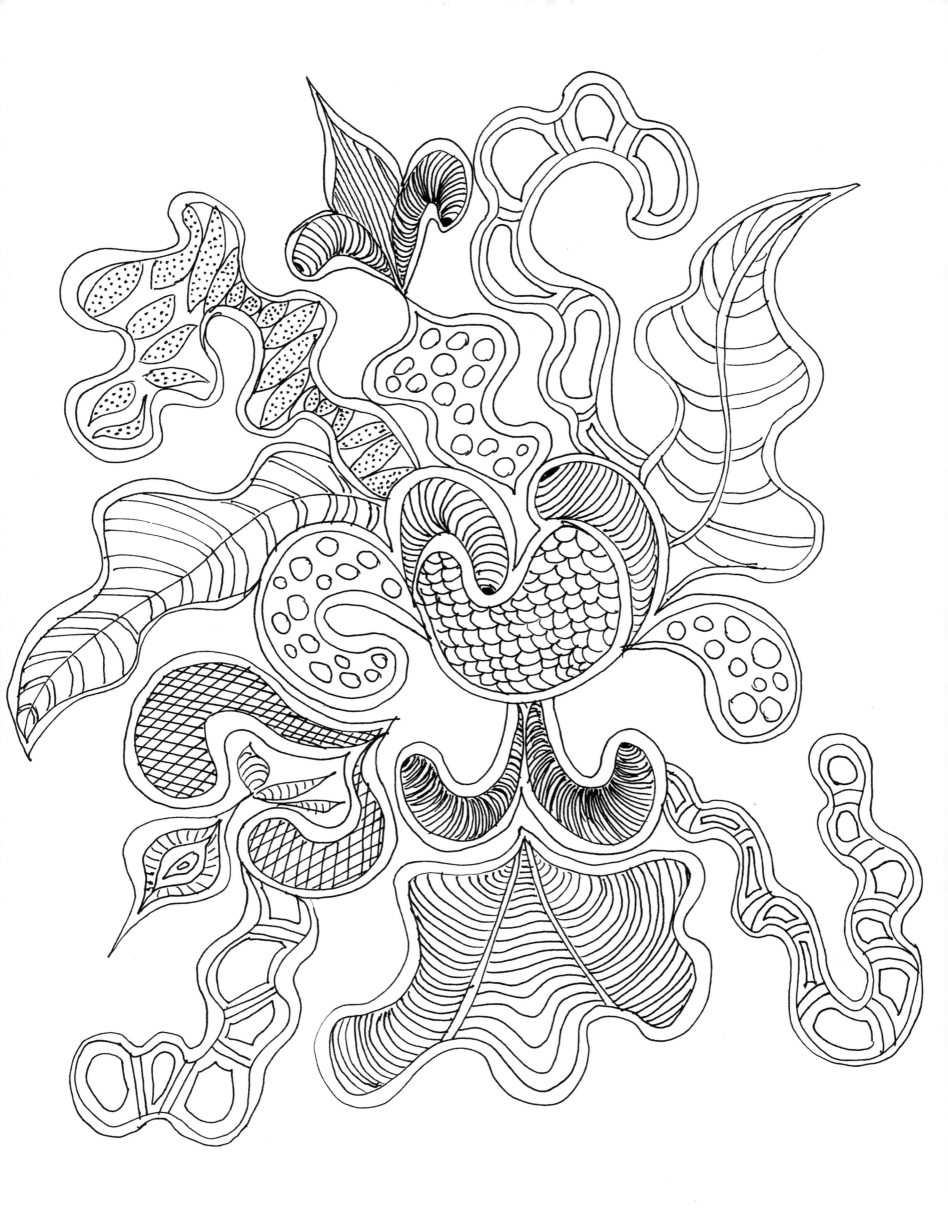

34

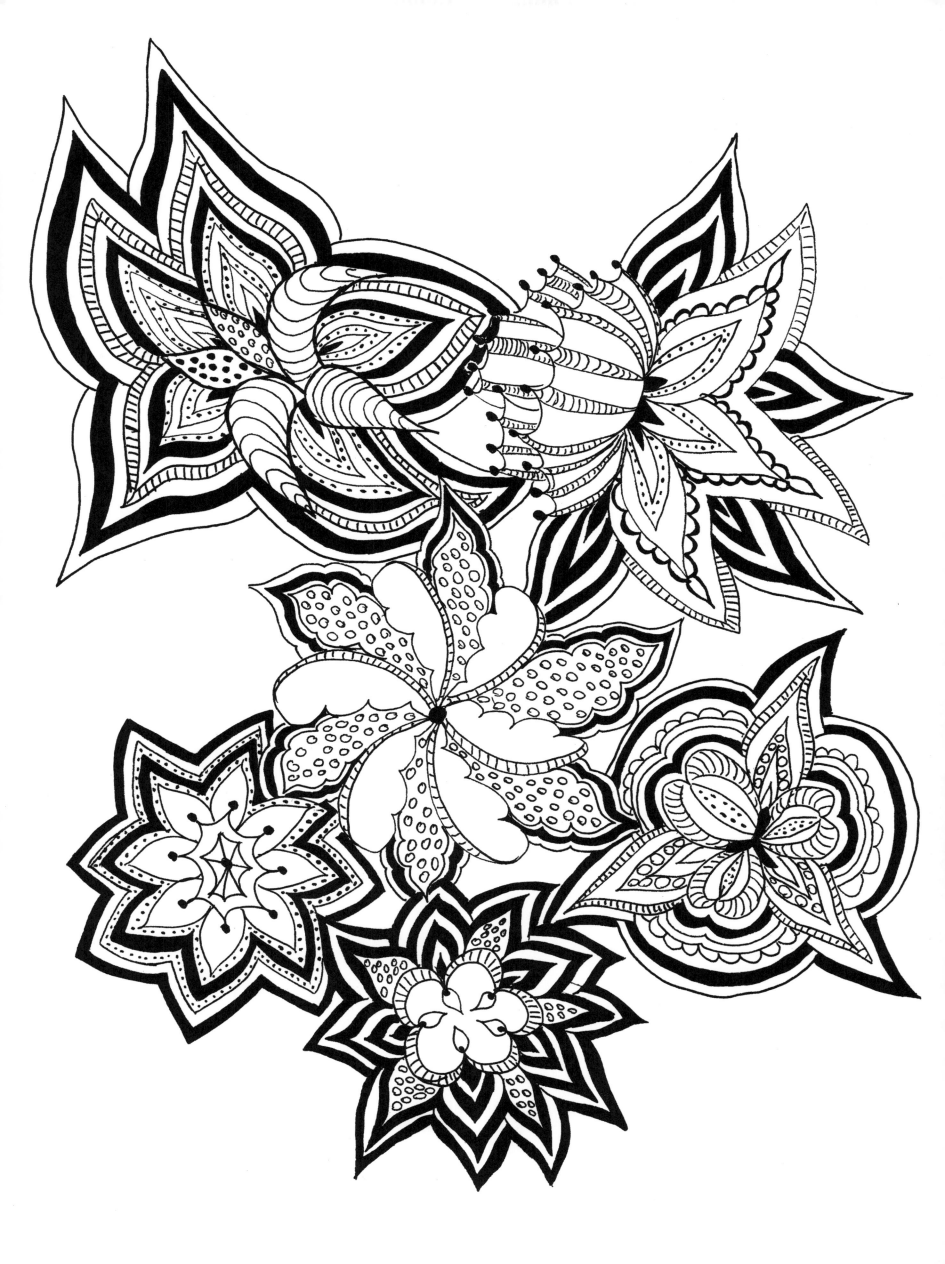

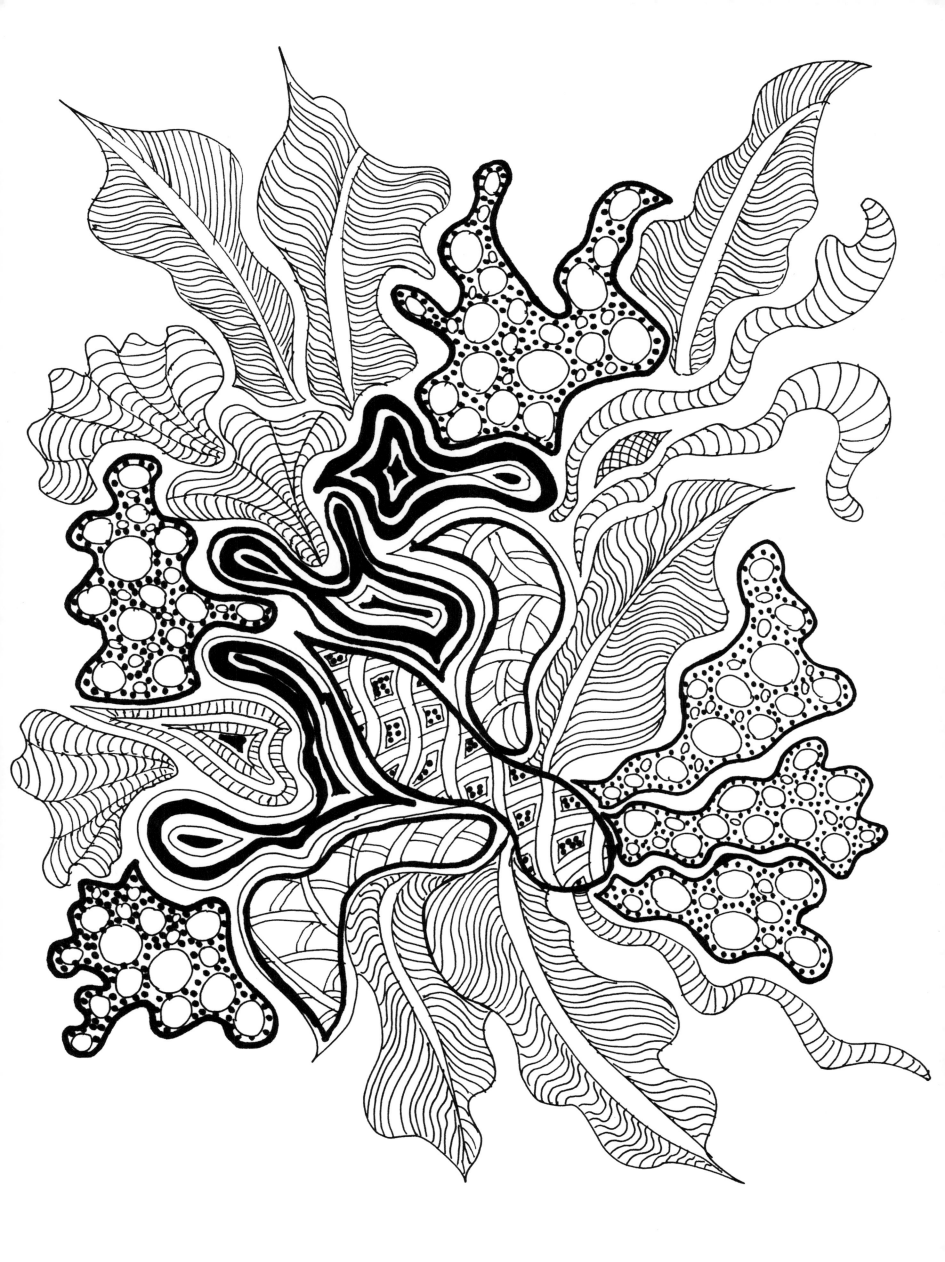

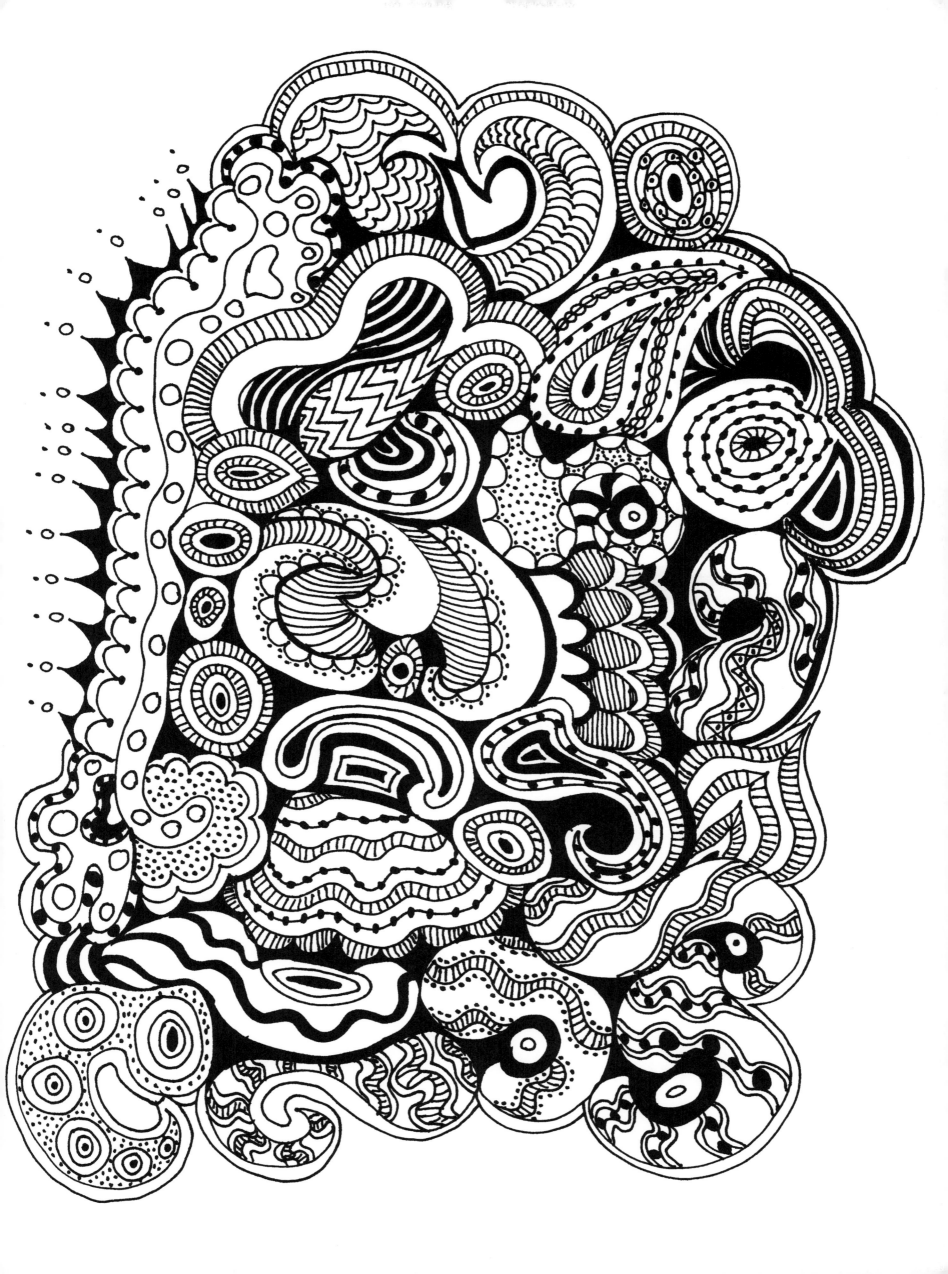

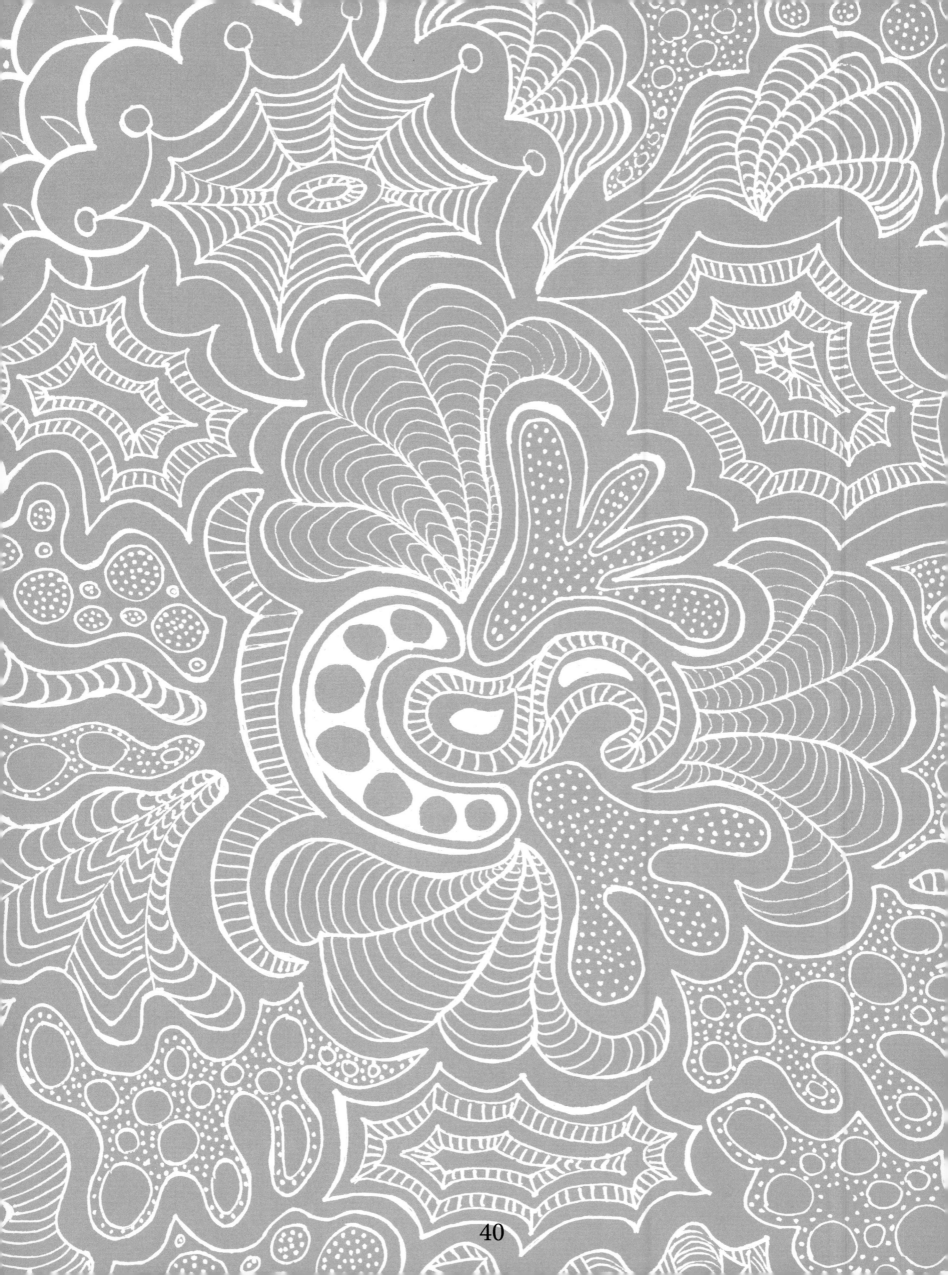

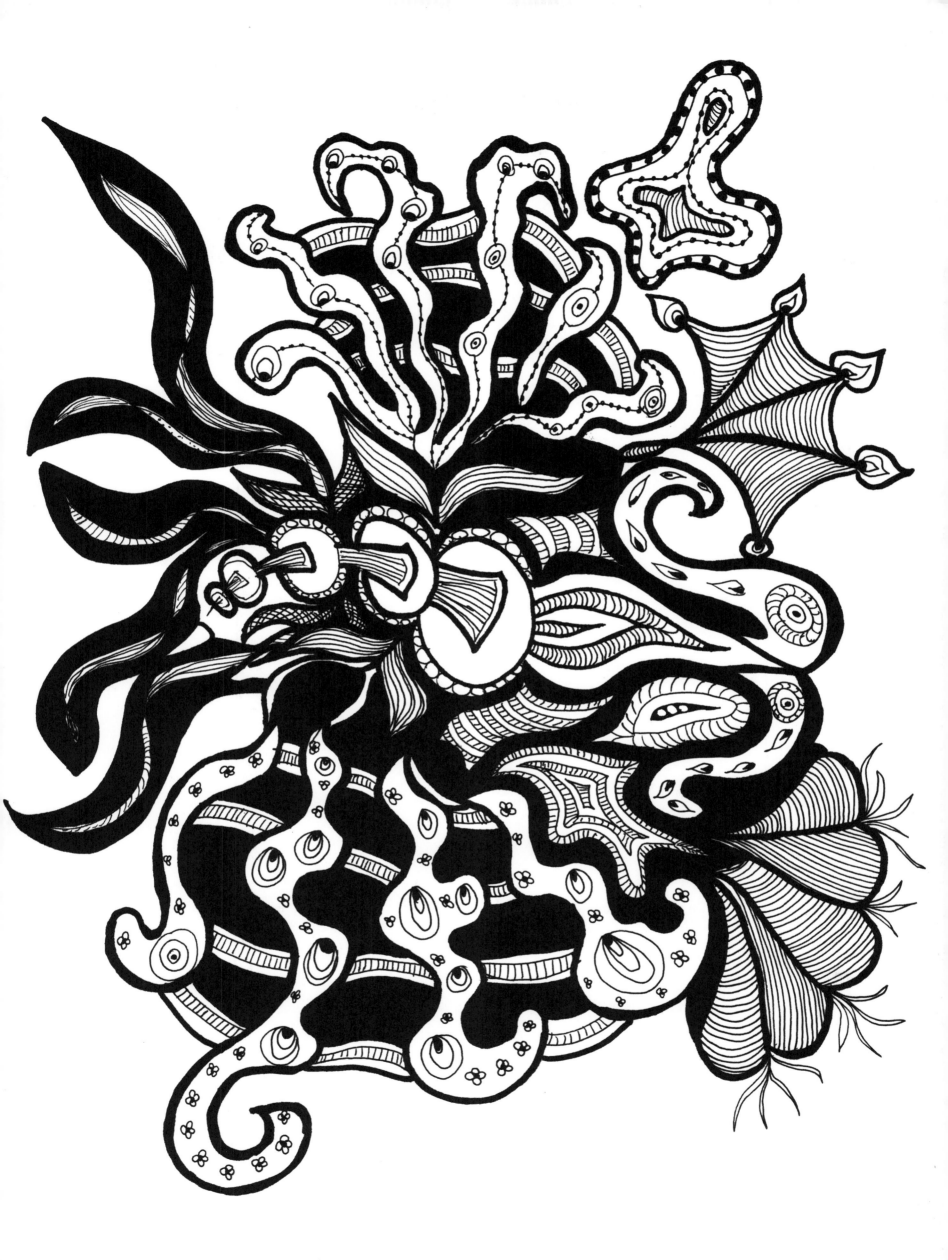

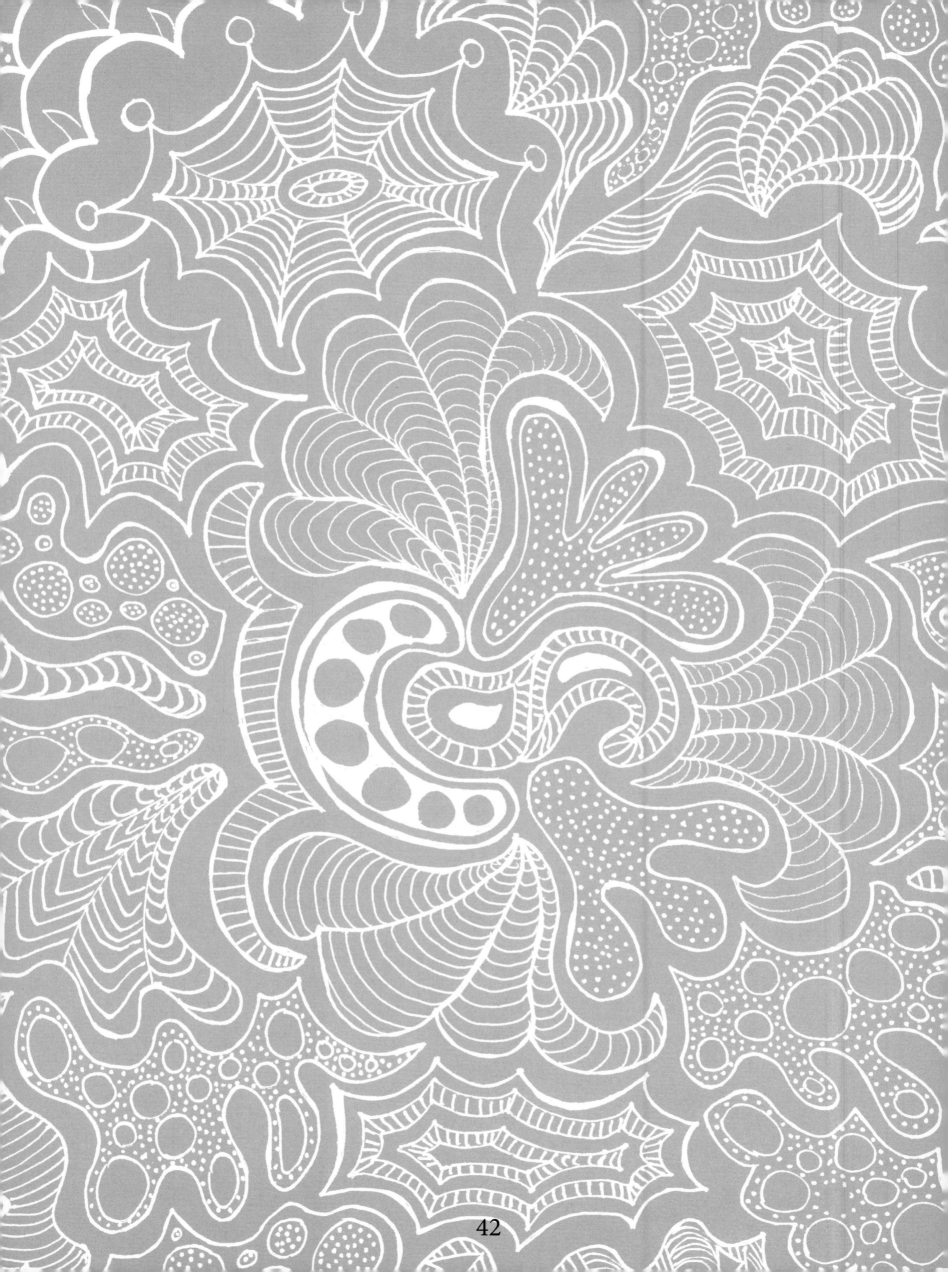

42

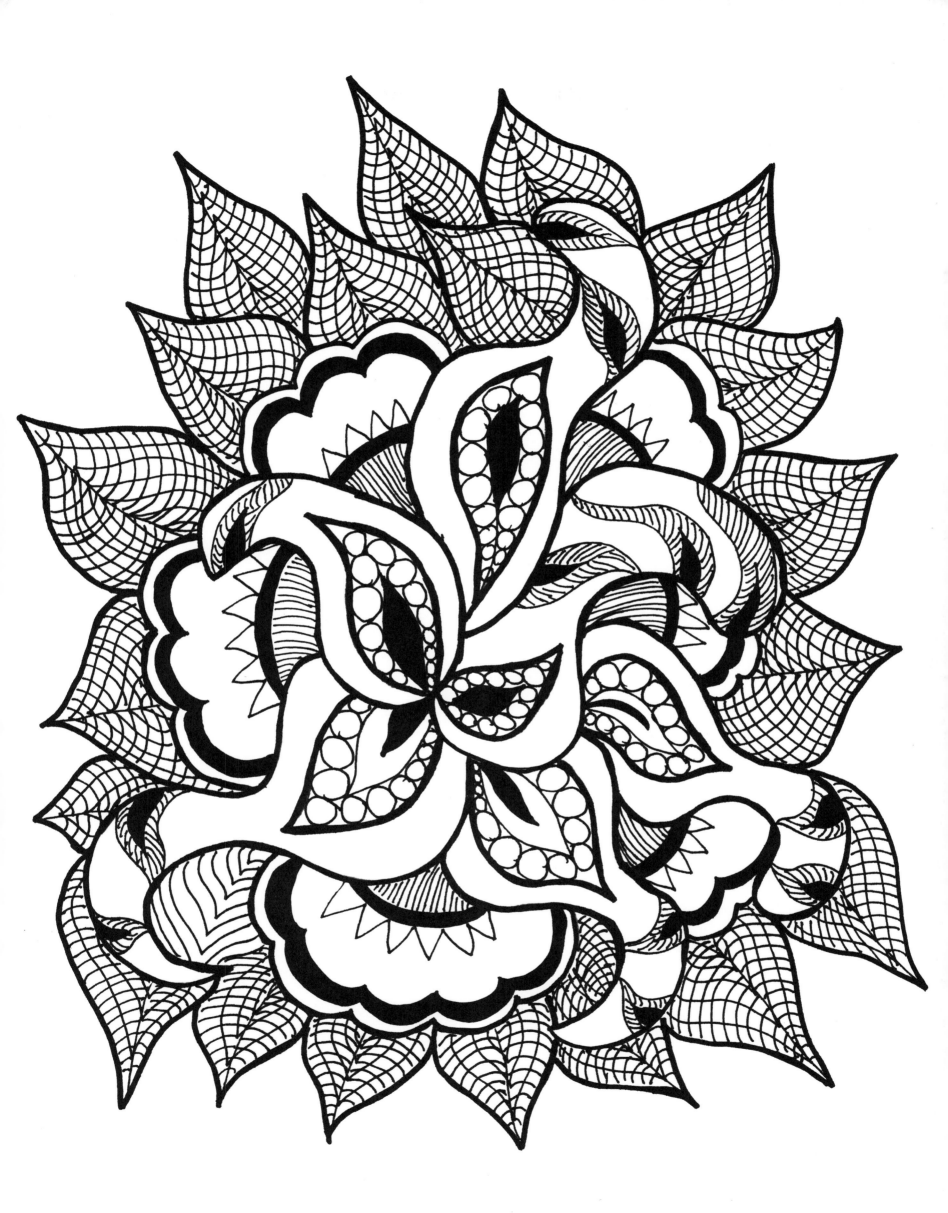

44

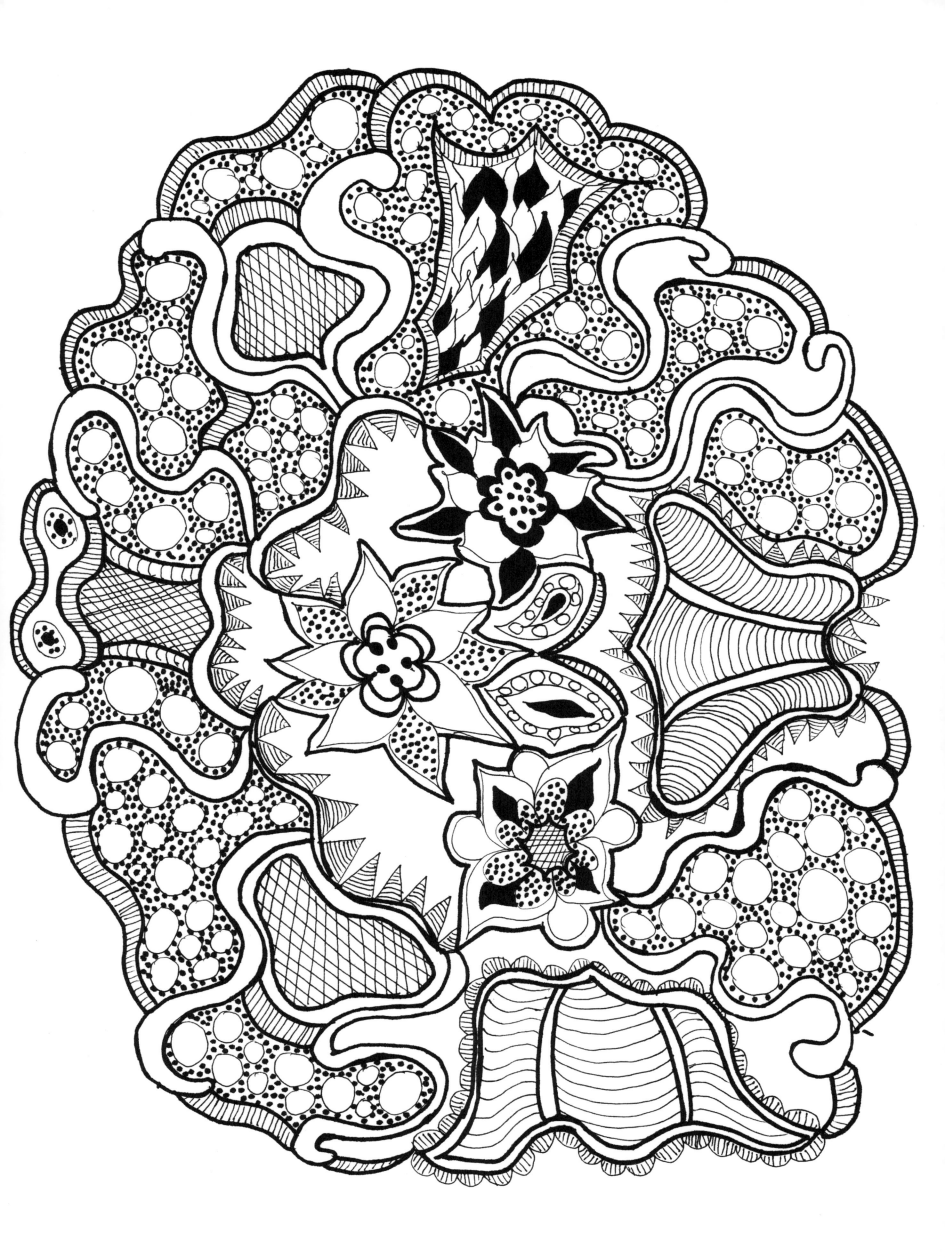

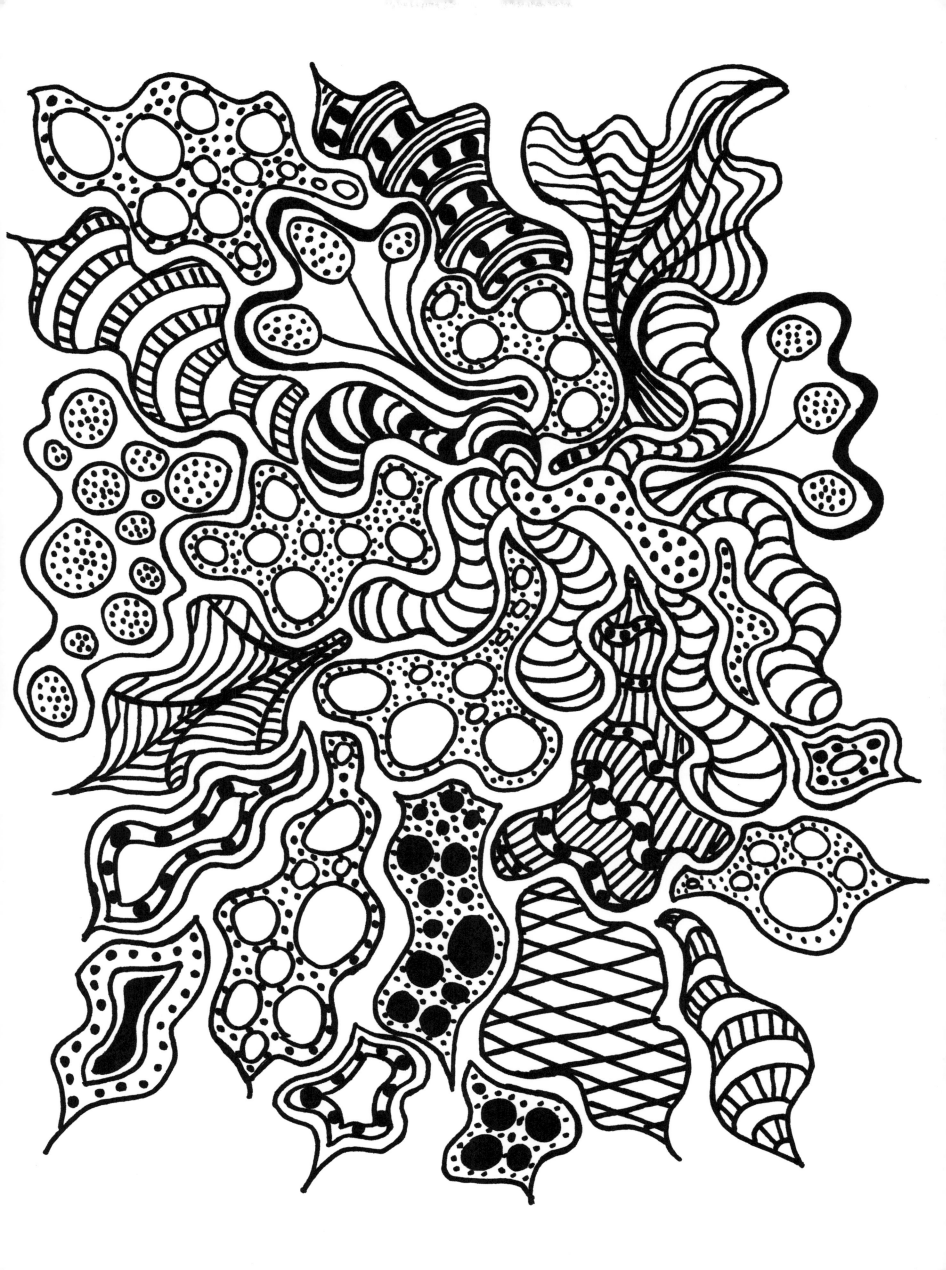

48

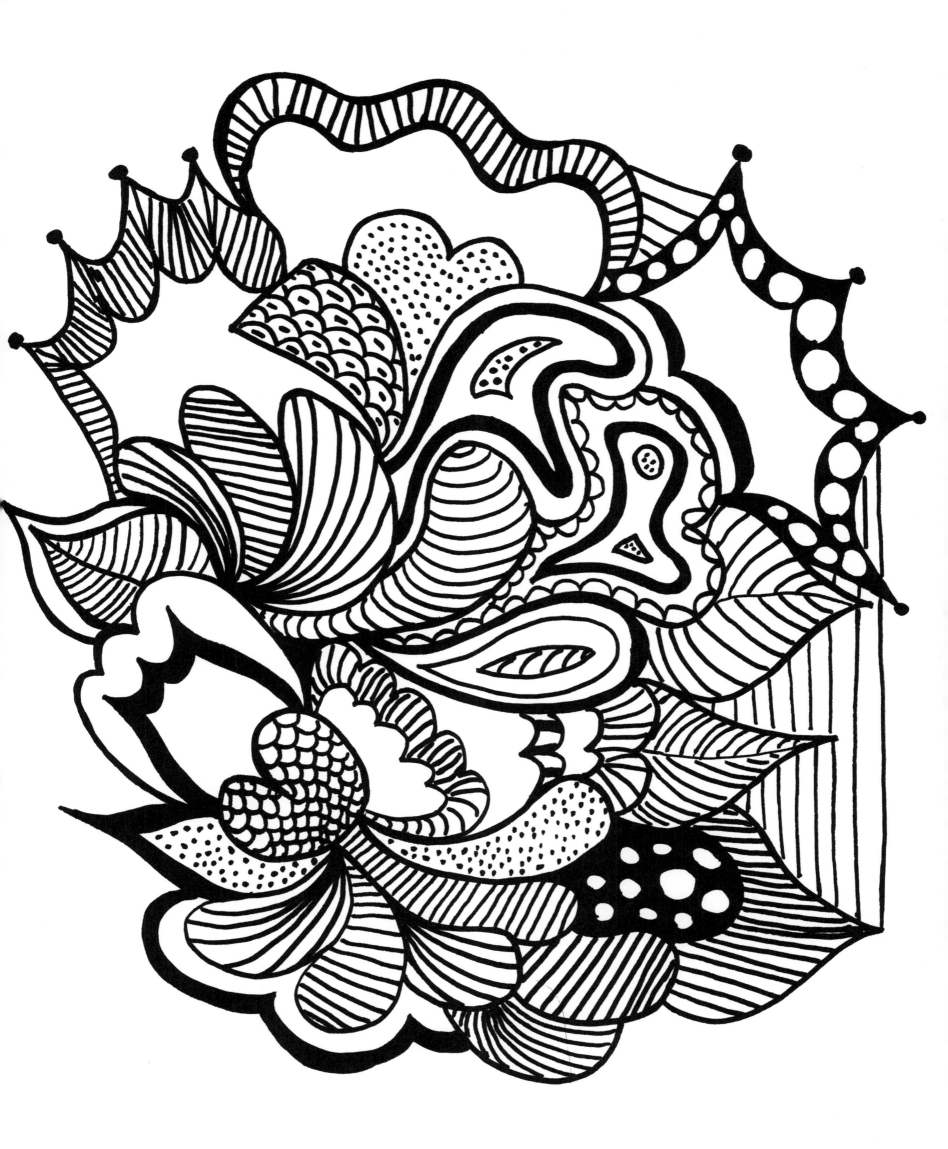

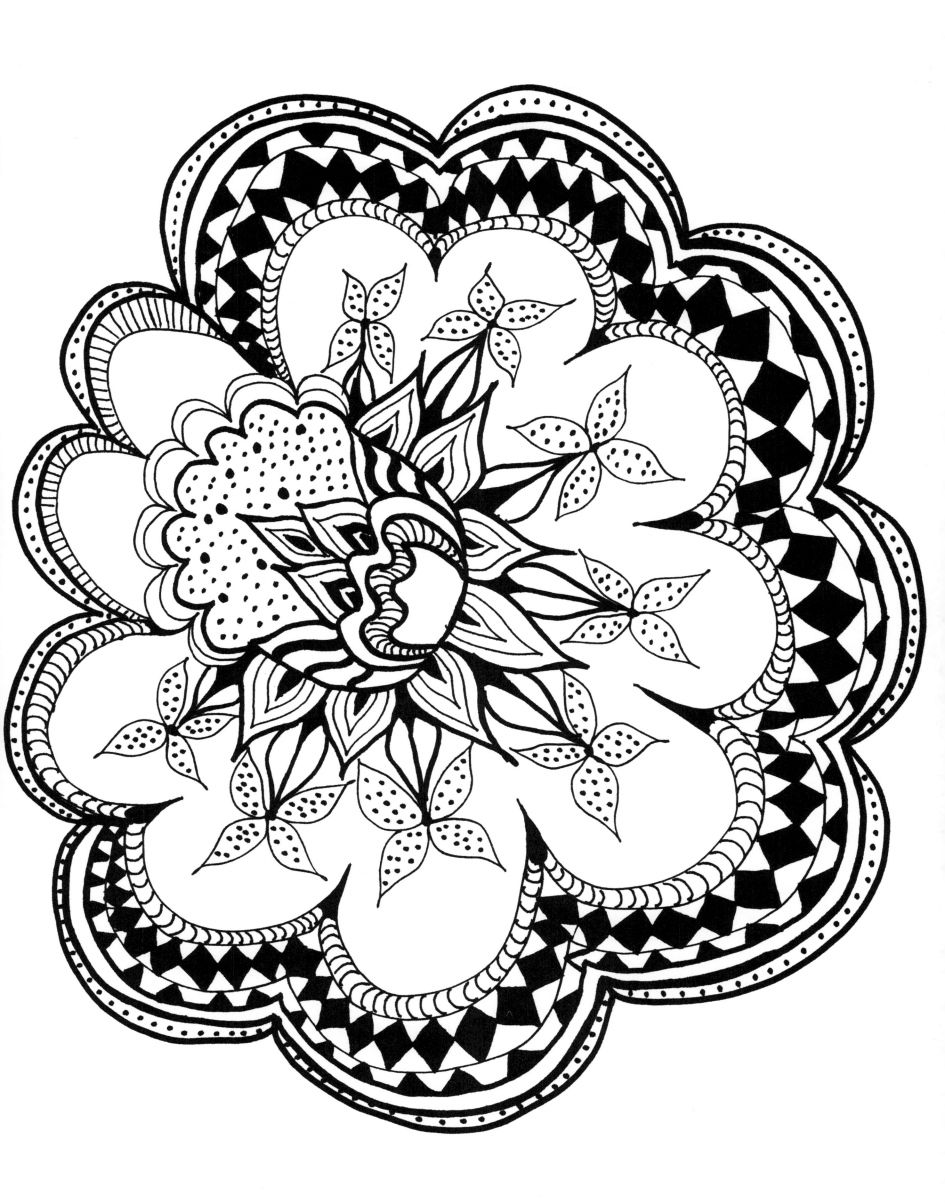

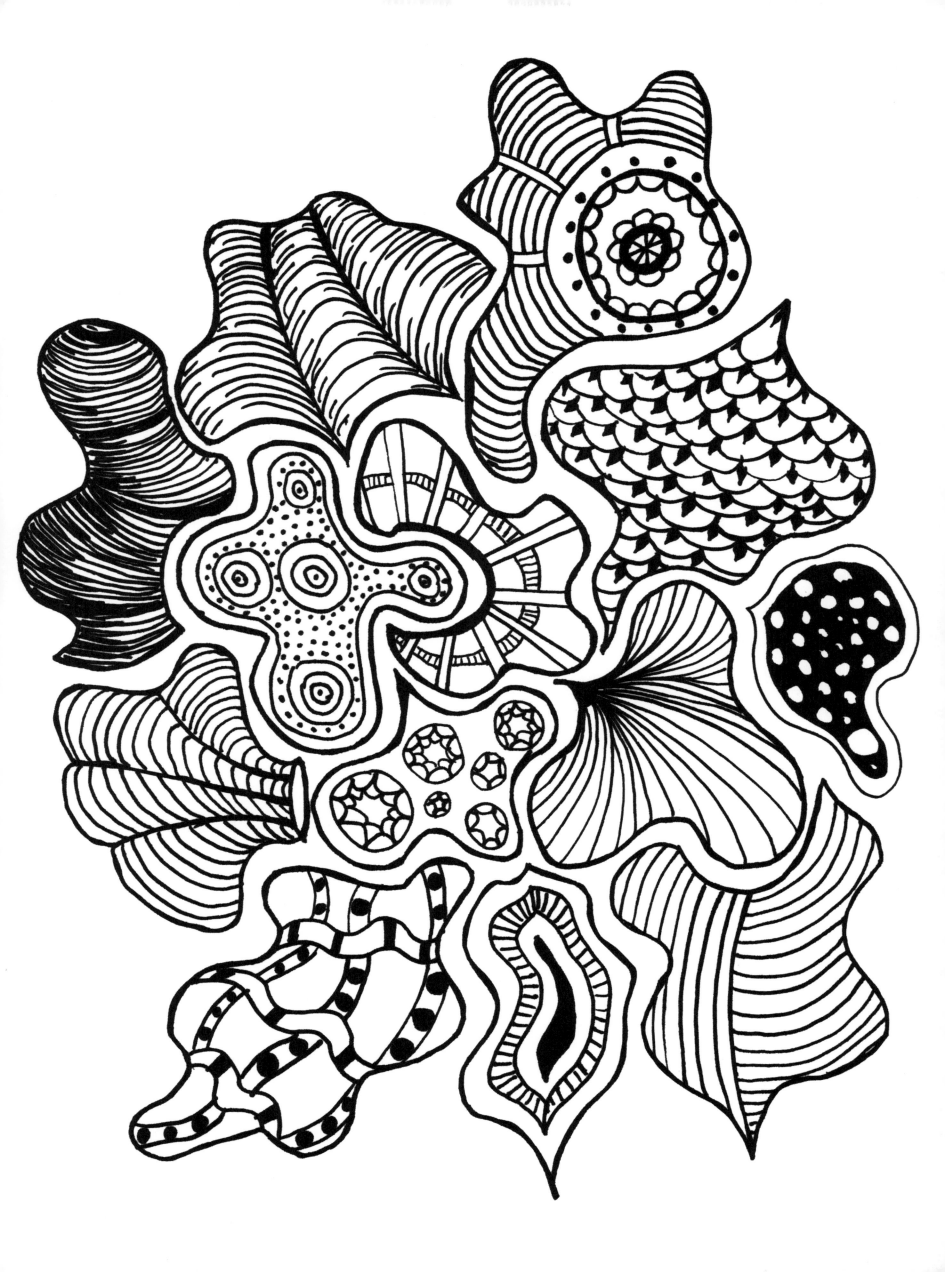

54

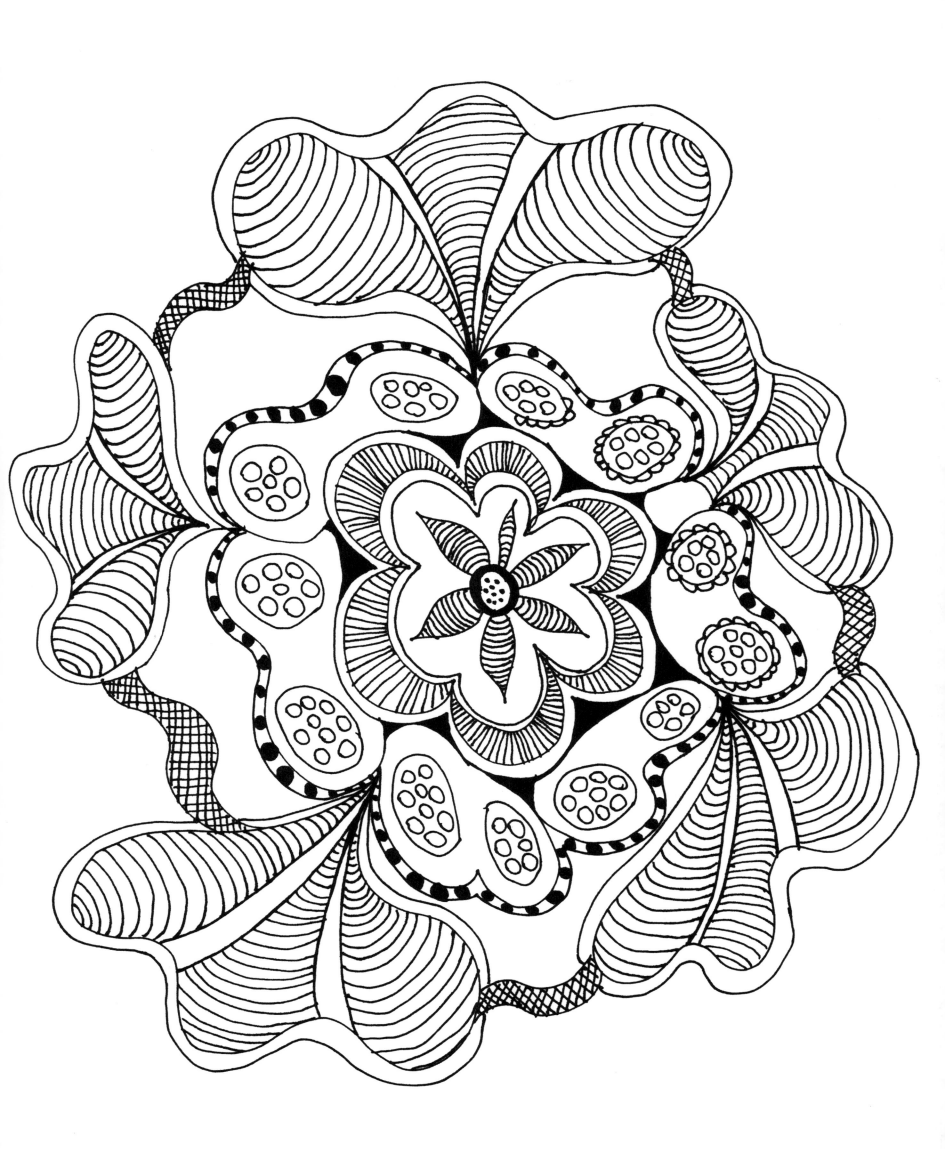

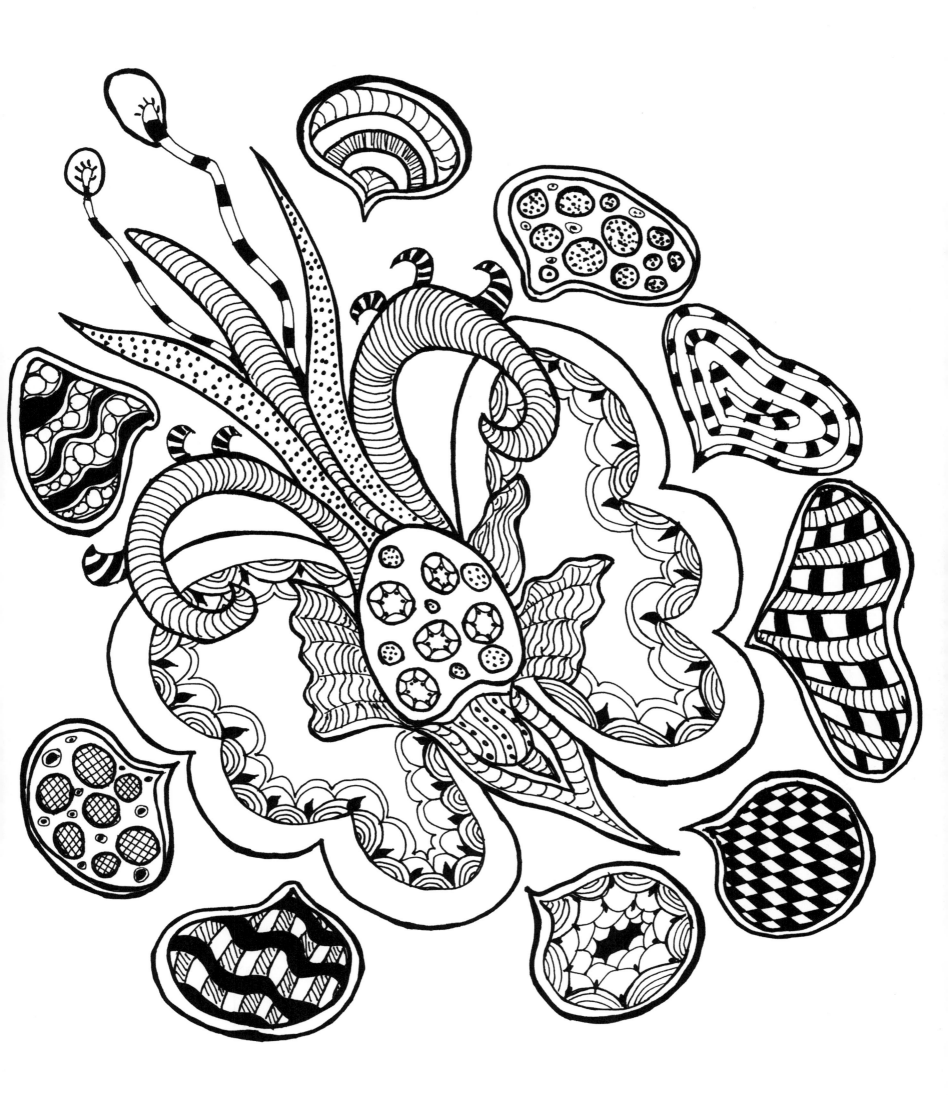

58

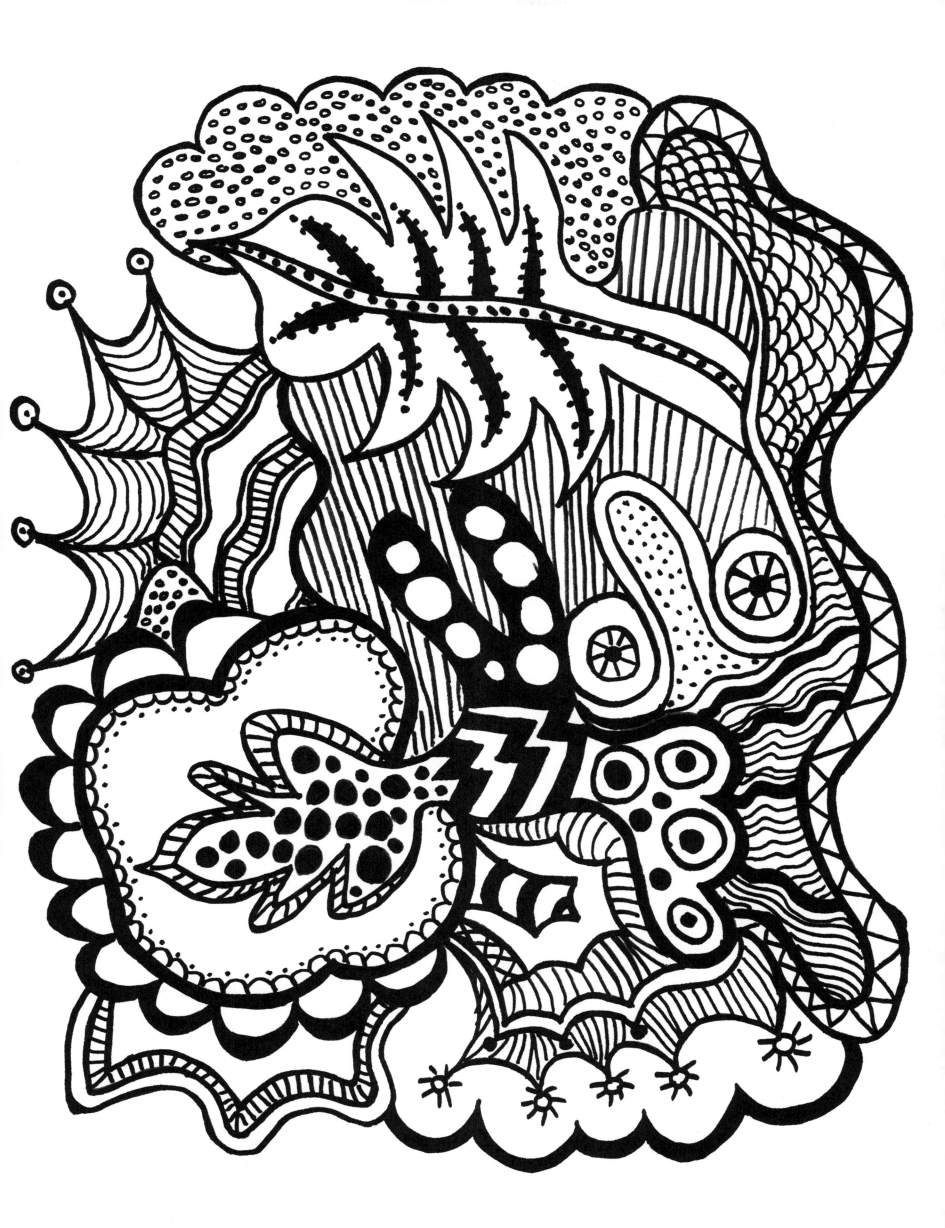

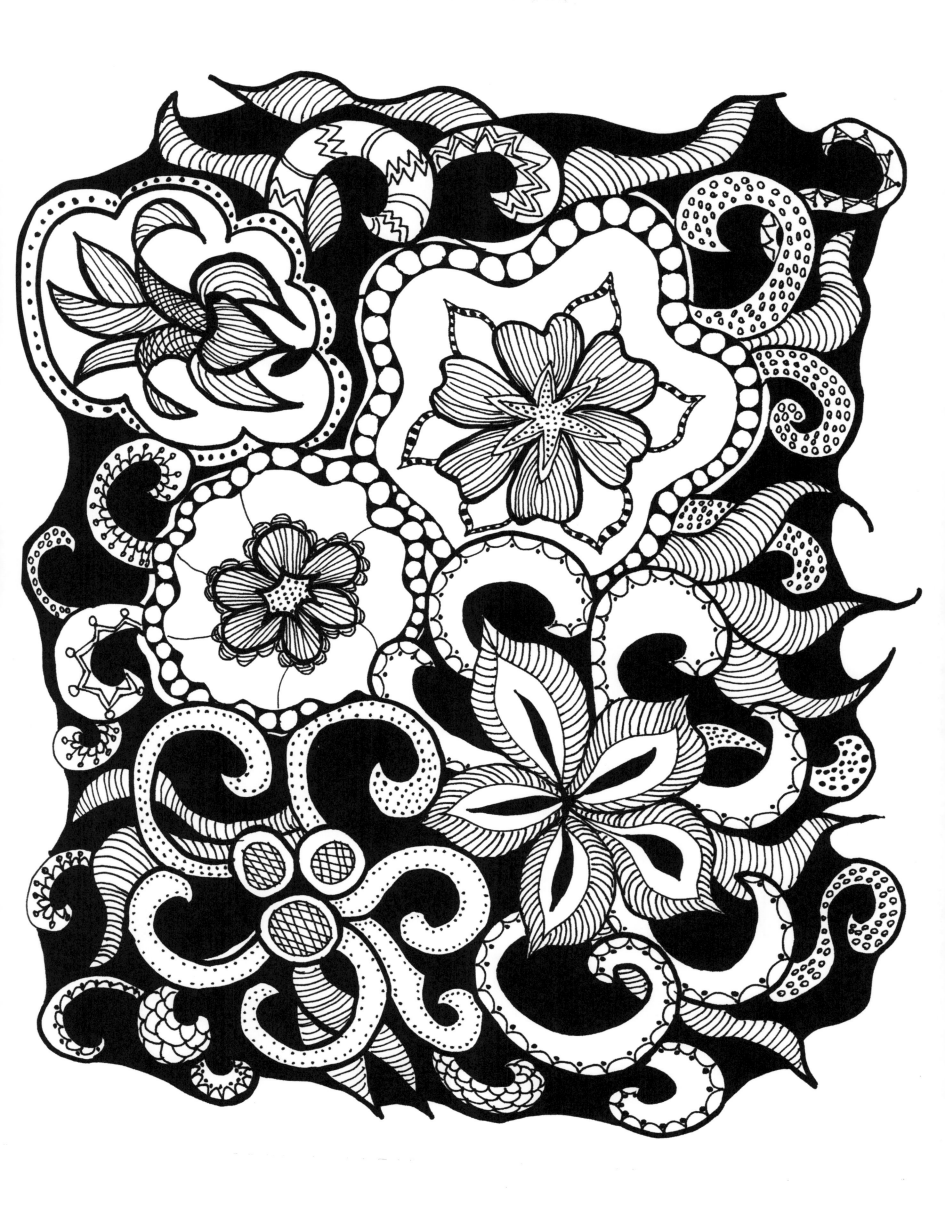

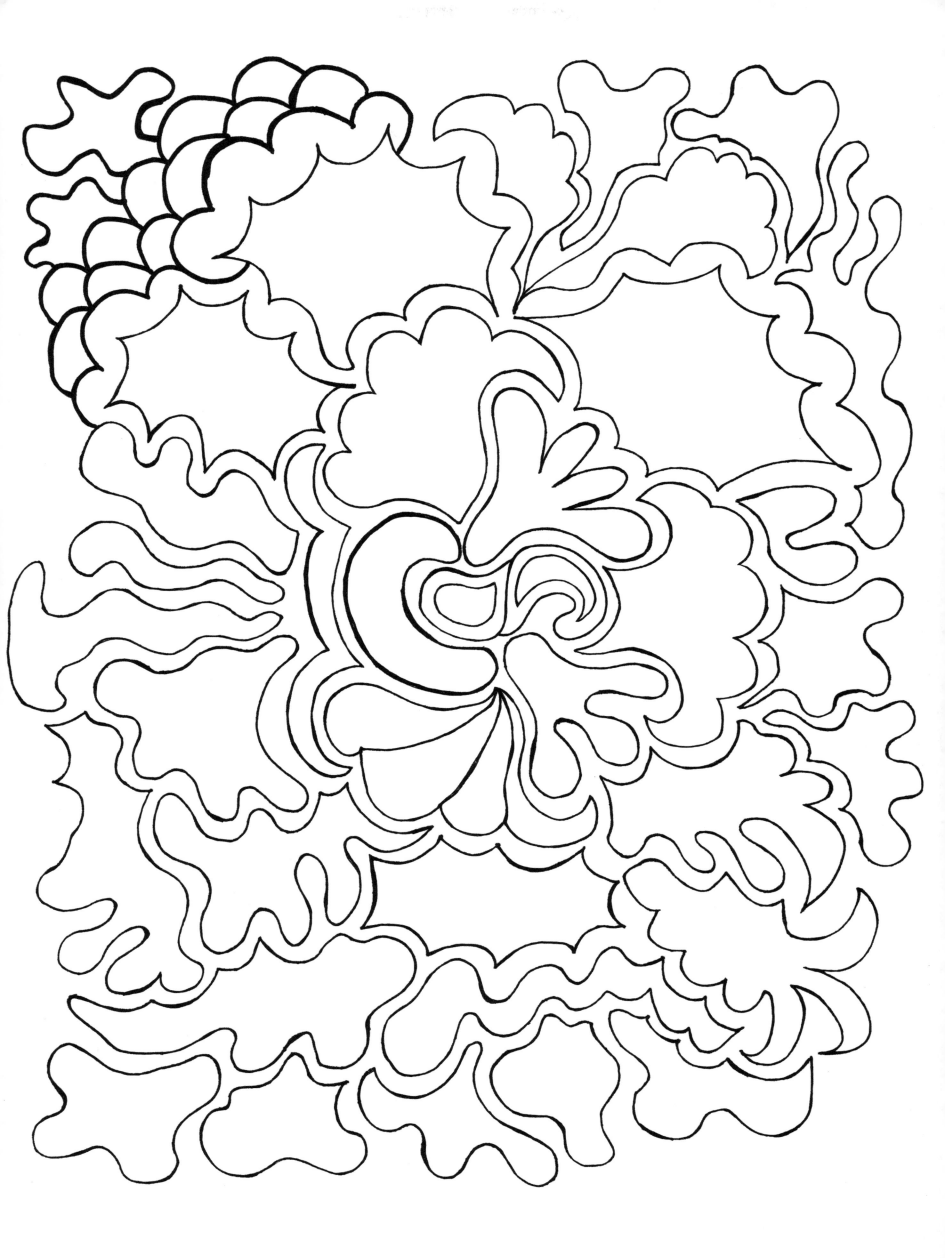

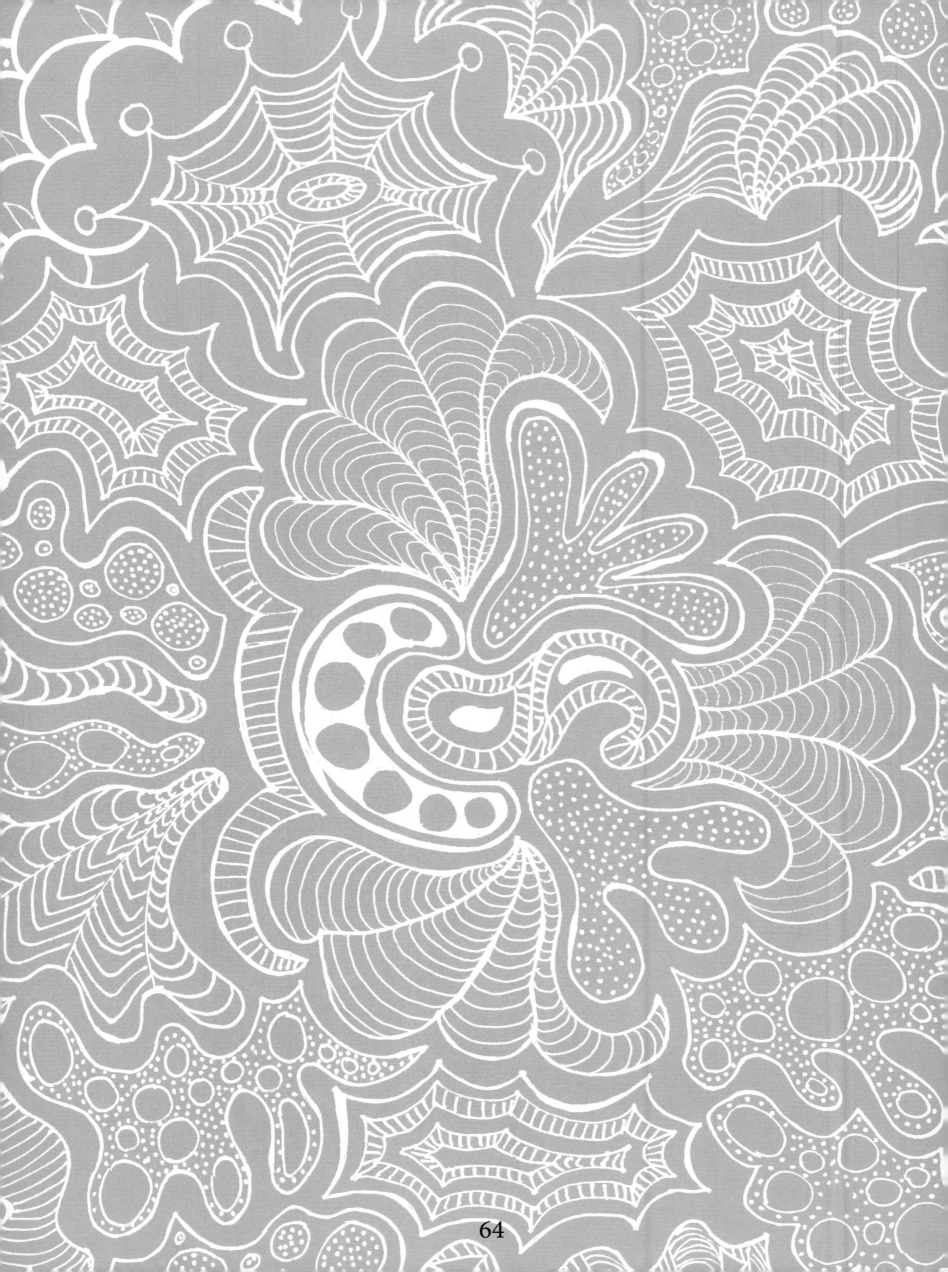

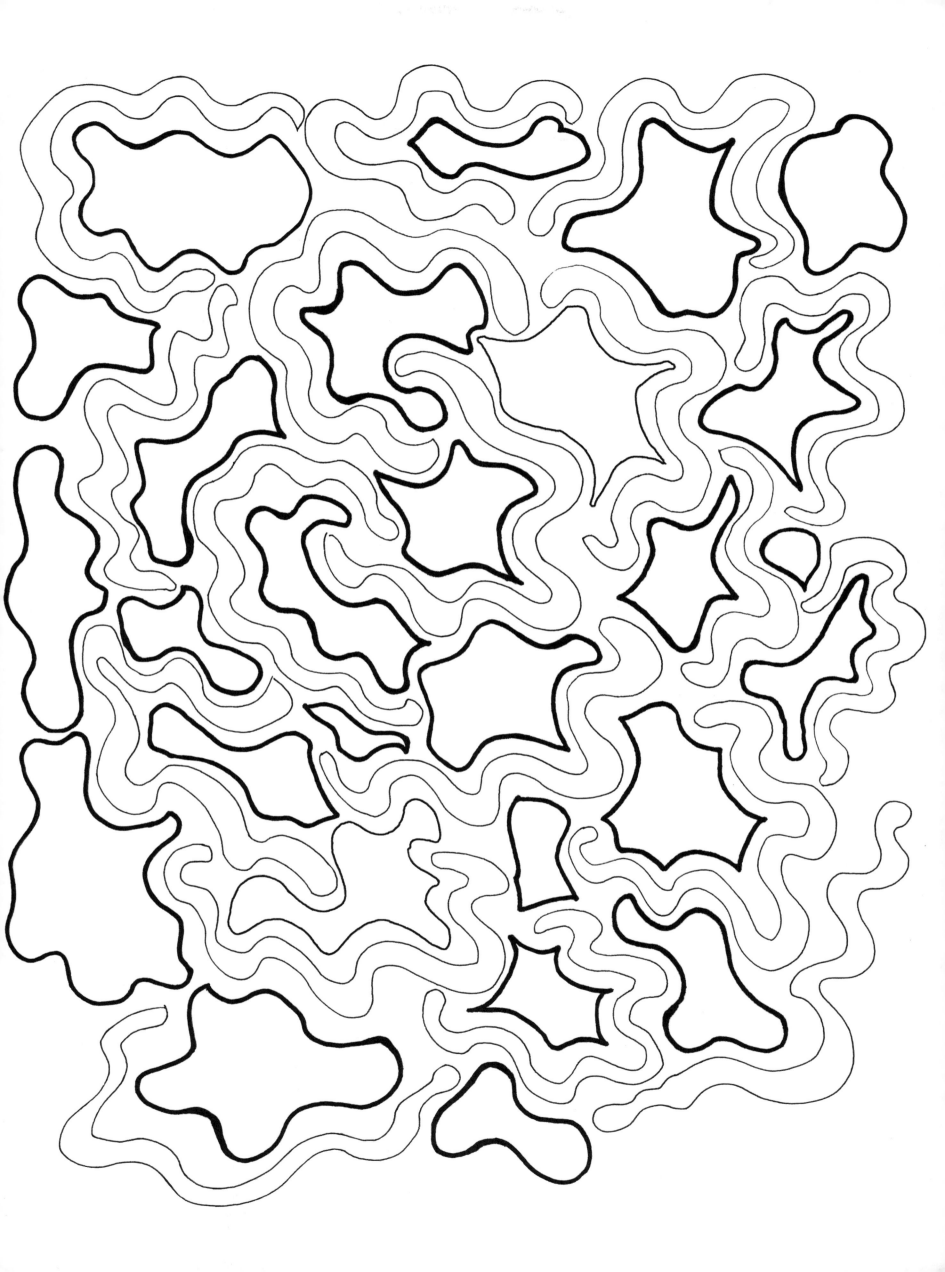

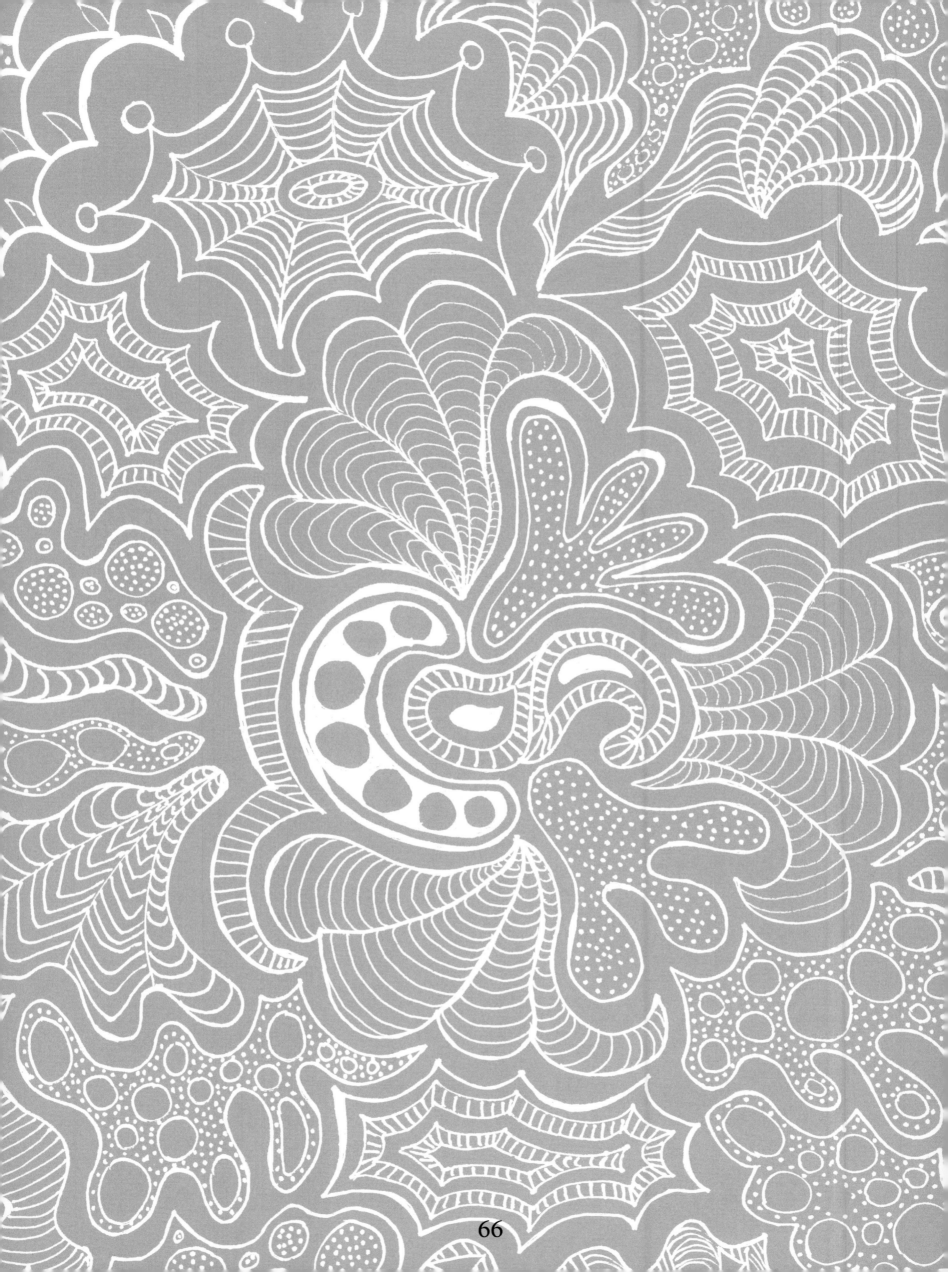

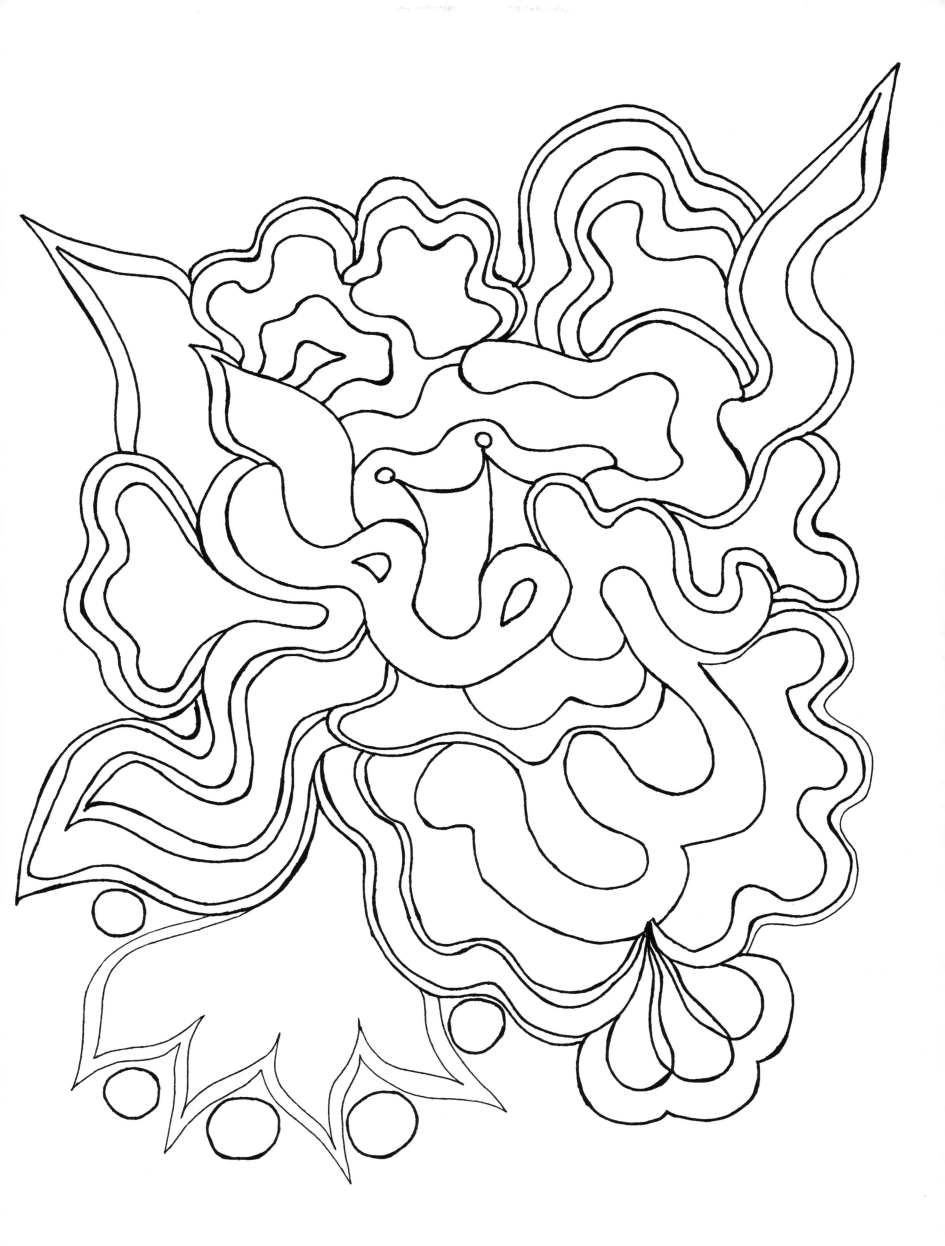

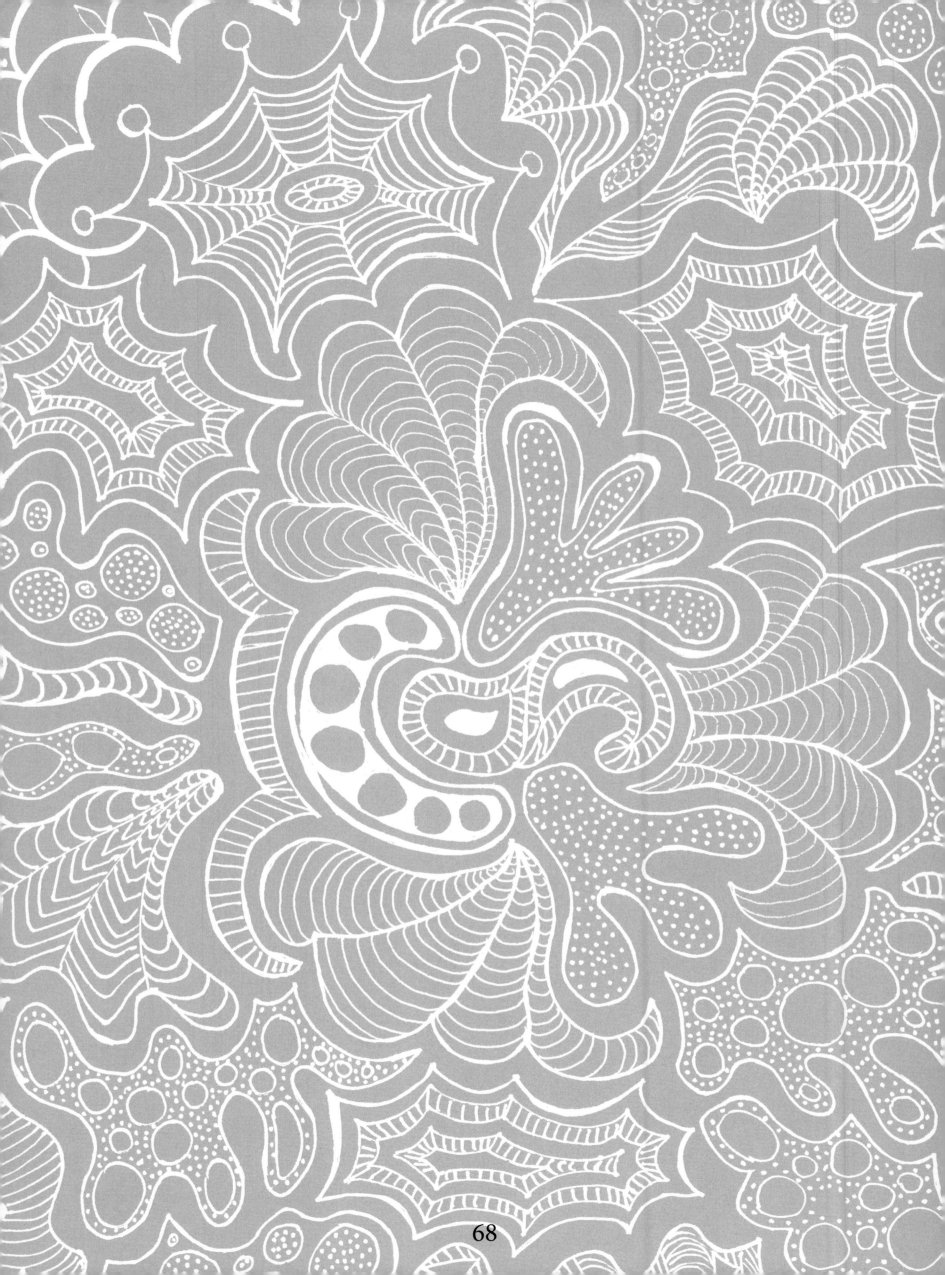

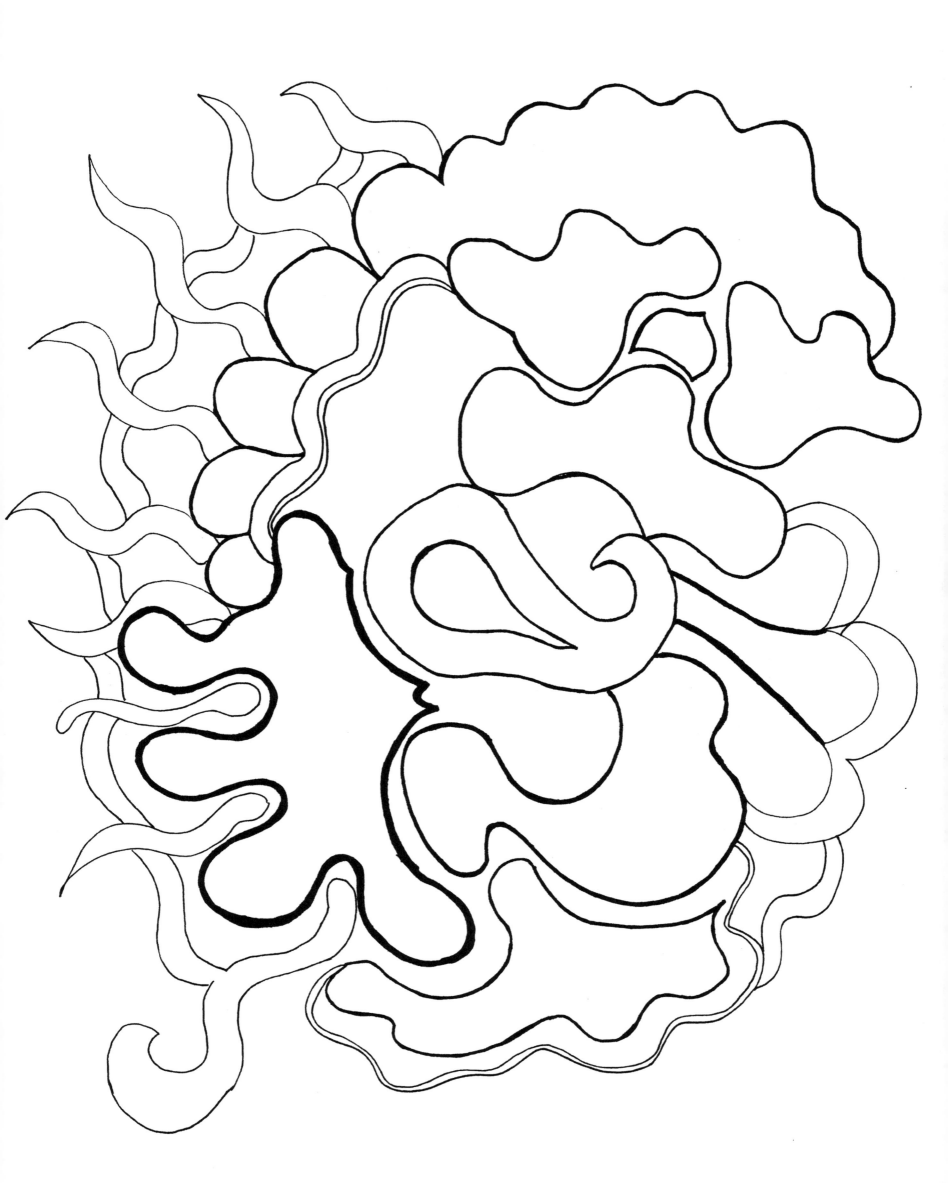

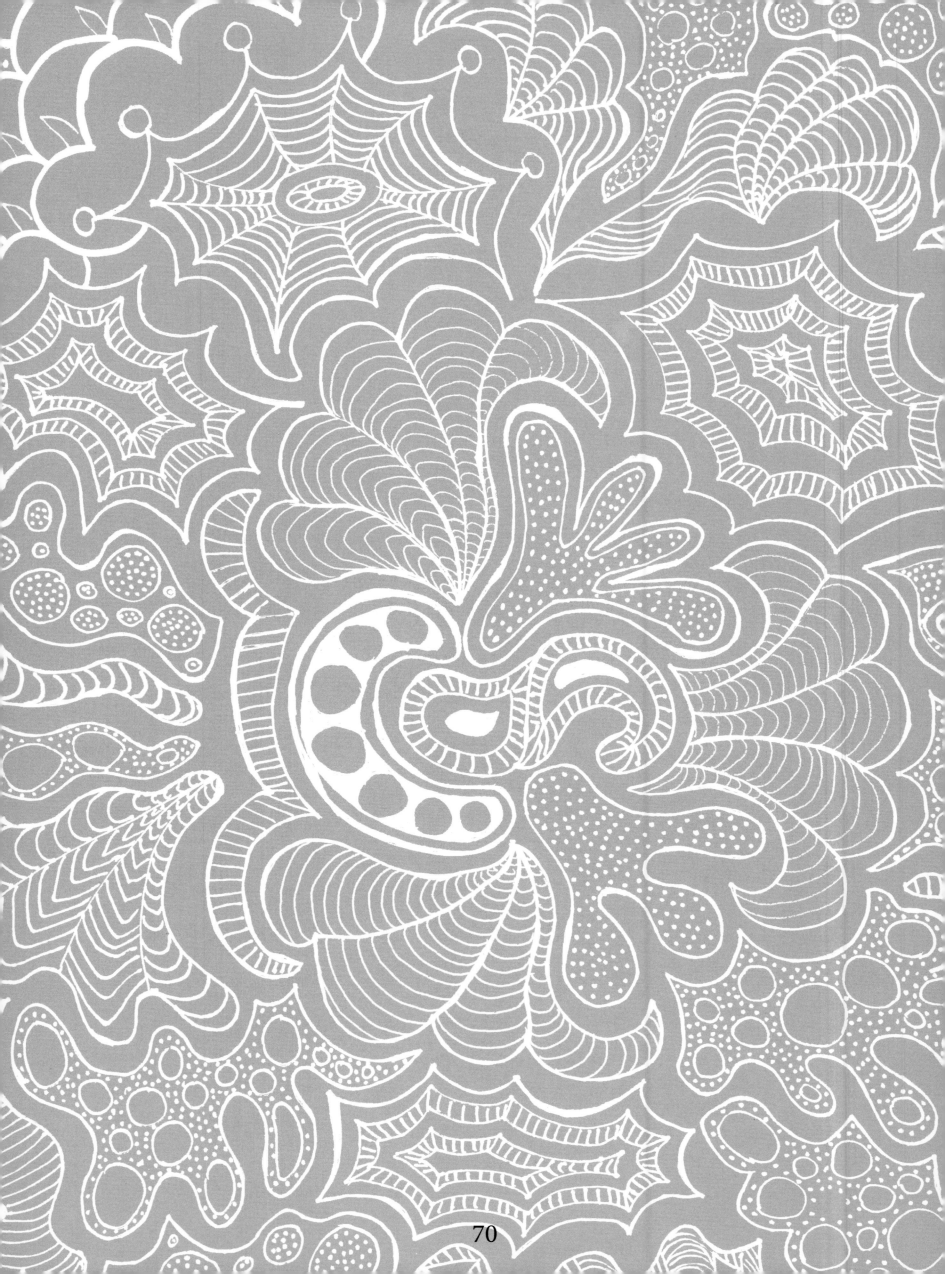

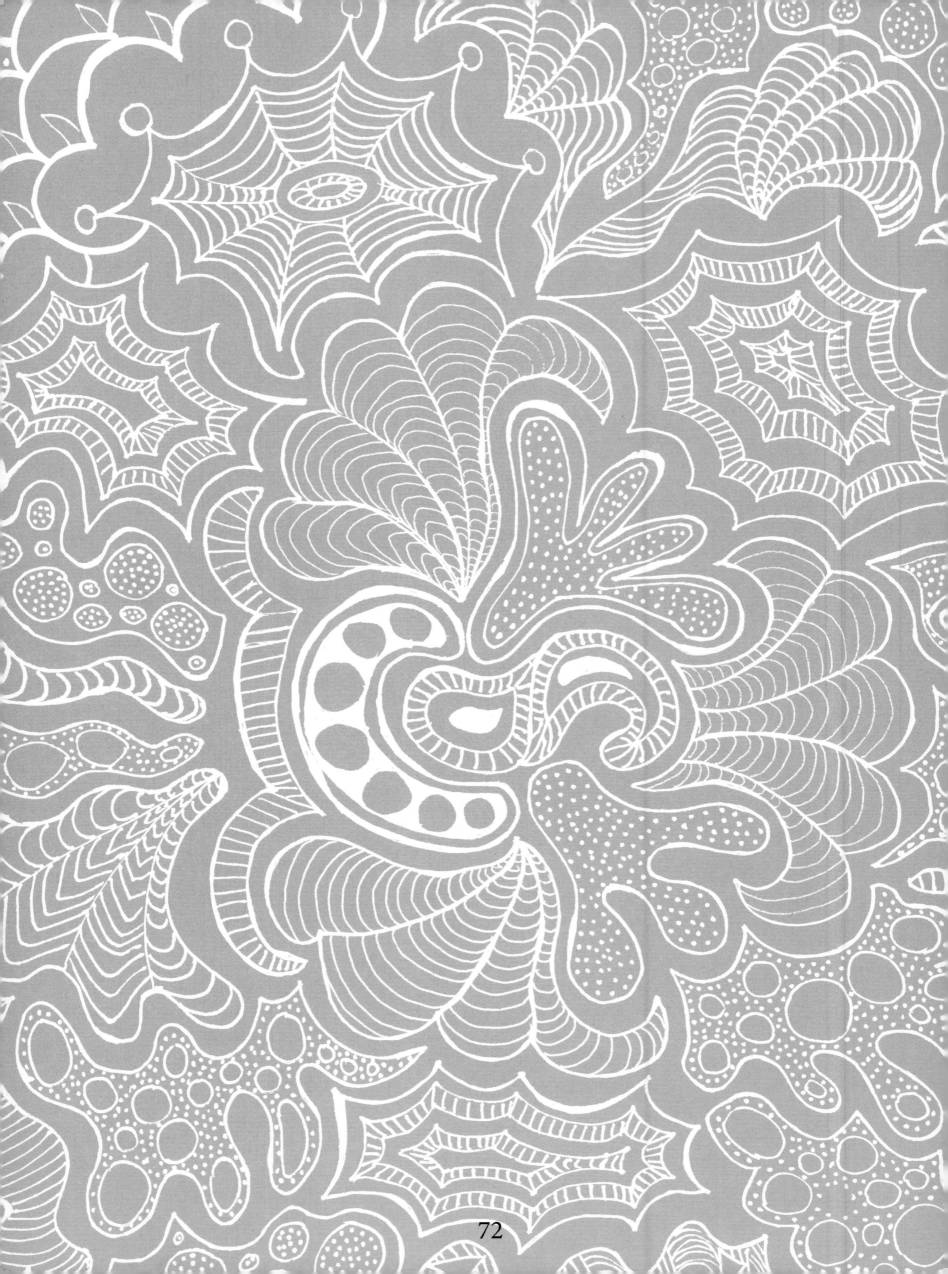